SEAFORD

THROUGH TIME

Kevin Gordon

AMBERLEY PUBLISHING

Acknowledgements

Many of the images in this book come from the archives of Seaford Museum and my own modest collection. The merry band of volunteers at the museum have assisted with much information.

I must thank Rosemary and Laurie Holland for permission to use images from their large collection of local postcards and Ben Franks for scanning them. John Eastlake, Jo Maddox, David Worsfold, Christopher Green and Rosmary Page have also provided pictures.

As ever, my lovely wife Mandy has been forever patient and helped me in so many ways (not least with my spelling!). My children, Toby and Emmeline have also given me their support and I dedicate this book to them.

Kevin Gordon
Seaford
November 2010

First published 2010

Amberley Publishing
Cirencester Road, Chalford,
Stroud, Gloucestershire, GL6 8PE

www.amberley-books.com

ISBN 978 1 84868 512 3

British Library Cataloguing in Publication Data.
A catalogue record for this book is available from the British Library.

Typeset in 9.5pt on 12pt Celeste.
Typesetting by Amberley Publishing.
Printed in the UK.

Introduction

I first came to Seaford as a child – and I thought it was a horrid place. My father has always loved a good storm and whenever a high tide coincided with some rough weather, we would drive over to Seaford to watch the spectacular waves crashing over the Esplanade.

I married, started a family and moved to Seaford in 1993 and within weeks I had joined the History Society, which was based at the splendid Martello Tower. The Society was formed by Ken and Joan Astell, who had worked hard in the 1970s to ensure that the heritage of this ancient town was preserved.

At the Museum I met two keen local historians Pat Berry and John Odam, who inspired me to find out more about my new hometown. They worked in different ways; John spent hours reading archive records whereas Pat liked to talk to old residents (and boy could she talk!)

Thanks to Pat and John I discovered that Seaford had been an ancient Cinque Port. (I also learned that Cinque is pronounced 'sink' – *'those that say "sank" instead of "sink" are enemies and should be sunk!'*)

The port was the largest in Sussex and made its money exporting wool from the downland sheep to the continent. The French sacked Seaford on many occasions during the 100 years war and many buildings including the parish church were destroyed.

During the sixteenth century the River Ouse was re-routed to Meeching (now Newhaven) and the last incursion by the French was repelled by local landowner Sir Nicholas Pelham.

It was politics that changed the fortunes of the town. As a Cinque Port, Seaford could return two Members of Parliament and the economy of the town was boosted by the regular elections. Three Seaford MPs were Prime Ministers, Henry Pelham (who replaced Walpole to be the second PM), William Pitt the Elder and George Canning.

The Napoleonic threat saw not only the Martello Tower but two large batteries were erected overlooking the sea. At one of these Colonel Coote Manningham established the Rifle Brigade – now the Royal Green Jackets.

In Victorian times although Seaford tried to attract visitors to take in the sea air, it could not compete with nearby Brighton or Eastbourne, so instead large areas were taken over by schools. By 1900 there were dozens of pre-preparatory schools in the town and they became the main employer, providing work to local gardeners, laundries and other domestic workers.

During the First World War two huge army camps were established in Seaford and thousands of men travelled from all over the empire (particularly from Ireland, Canada and the West Indies) to train here.

After two large estates were sold, Seaford saw a rapid expansion and today it is the largest town within Lewes District Council, home to some 24,000 people. The town has its own local Council and there are many clubs and organisations who help to promote this vibrant town.

The beautiful scenery of Seaford Bay blends with that of the surrounding downland – soon to become a National Park. Seaford a horrid place? How wrong I was!

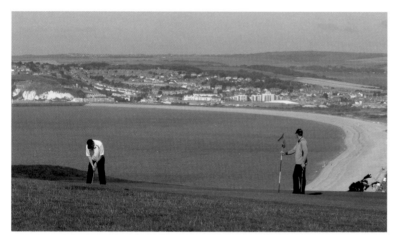

A game of golf overlooking the bay at Seaford.

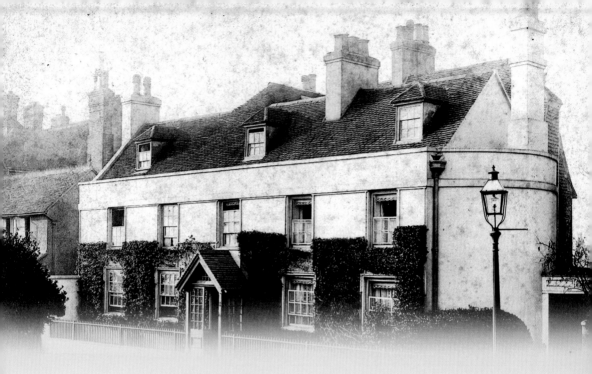

CHAPTER 1

Buildings

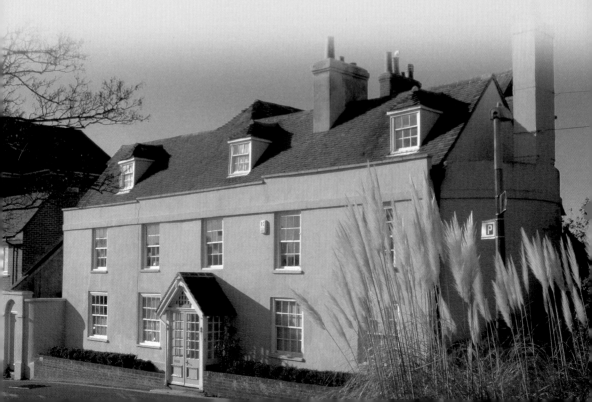

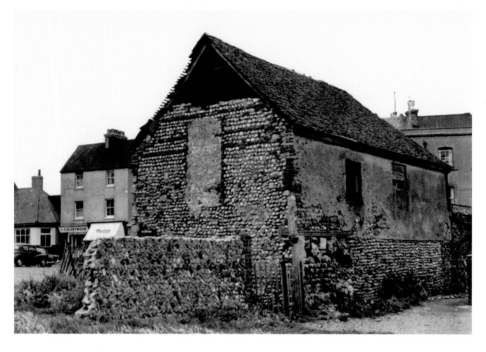

The Crypt

This thirteenth-century undercroft was once the working cellar of a rich wool merchant at a time when Seaford was the largest port in Sussex. It survived when buildings around it were destroyed by the Luftwaffe in the Second World War and in 1994 became an art gallery. Seaford Town Council took over running the venue. In 2010 and it was rebranded 'art@thecrypt' hosting events, exhibitions and displays such as this sound and light installation by Seaford artist Jo Allen.

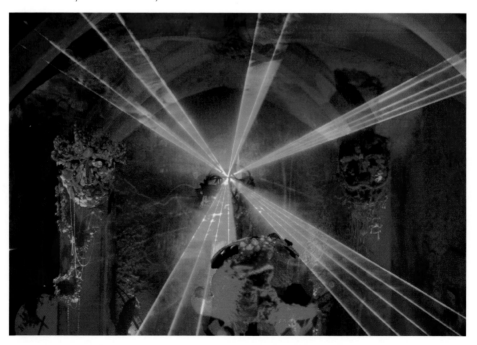

The Workhouse

This view of the Seaford workhouse was taken in 1878 from Clinton Place, with the photographer probably standing where Tesco is today. The line of trees to the top of the picture is Blatchington Hill and the spire of St Peter's Church can just be seen. The workhouse was built on the Spital Field, once the site of the Leper Hospital. When the residents were moved to Eastbourne in 1810, Twyn House (below) became a private residence.

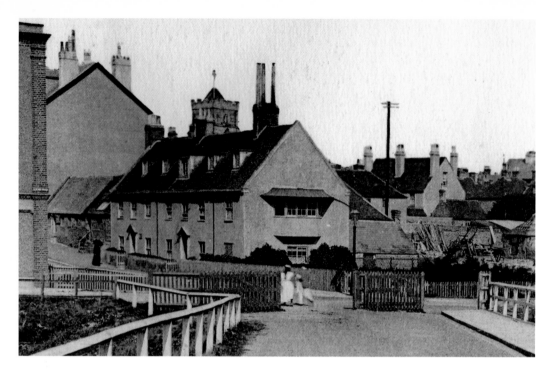

West House

Built in 1700, West House is one of the oldest surviving houses in the town. It was formerly a school, and in the 1970s housed Seaford Museum. A curious event took place annually at the gatepost in the foreground. Members of Seaford Corporation and the public gathered here every 29 September to hear the Sergeant-at-Mace declare the winner of the (fixed) election for Town Bailiff (Mayor).

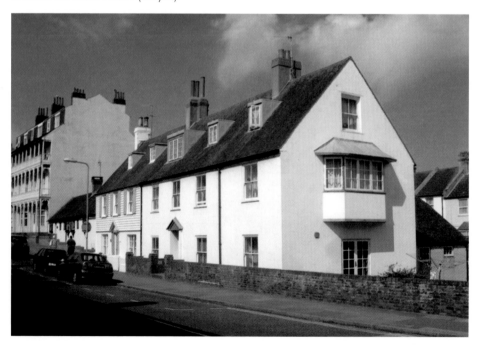

Town Hall

This eighteenth-century building was used by the Corporation of Seaford for its meetings. It also served as a court, mortuary and town gaol. (The small blue square at ground level is was once the barred window of one of the cells.) In December 1796 the crew of the French privateer *Hazard* were held in the gaol. It must have been cramped as it was described as the *Black Hole of Seaford*. Today the building is used as a drop-in centre for the St James Trust and serves a fine cup of tea.

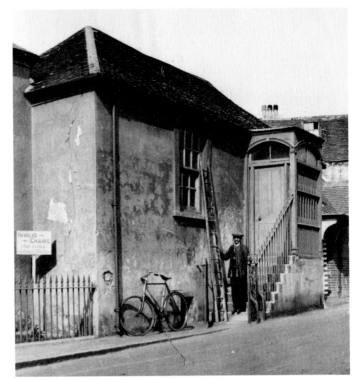

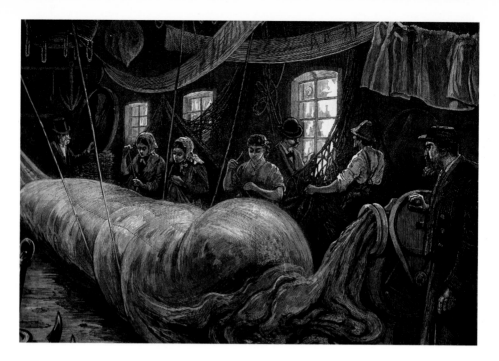

Balloon Factory

Henry Coxwell made his first balloon ascent at the age of nineteen and within eight years was editing a magazine called *The Balloon*. On 5 September 1862, accompanied by his friend Dr James Glaisher, he flew to a height of seven miles – a world altitude record. Coxwell lived in Seaford and established a balloon factory in Richmond Road and this print shows a balloon being made here in 1879. The following year he became the first person ever to have made 1,000 flights. Henry Coxwell died in 1900 and a memorial was erected at St Peter's Church in East Blatchington. In 2009 a new road was called Coxwell Close in his honour.

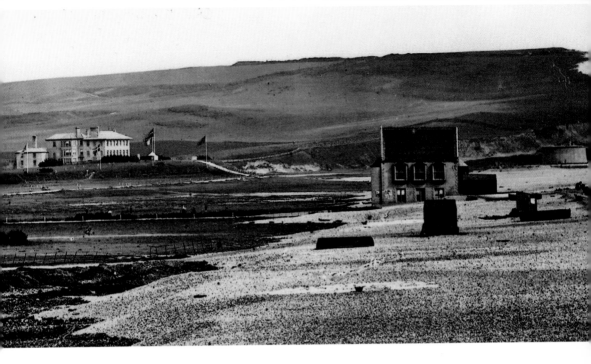

Corsica Hall

This view of the eastern end of the Esplanade shows Corsica Hall, the Assembly Rooms (1770) and the Martello Tower (1808). The original Corsica Hall was cheekily named after the Corsican wines smuggled into Seaford by its owner. It was rebuilt in 1823 by John Purcell Fitzgerald who in 1875 used the building to house residents after their homes were ruined in the Seaford Flood. Fitzgerald was MP for Seaford from 1826 until disenfranchisement in 1832.

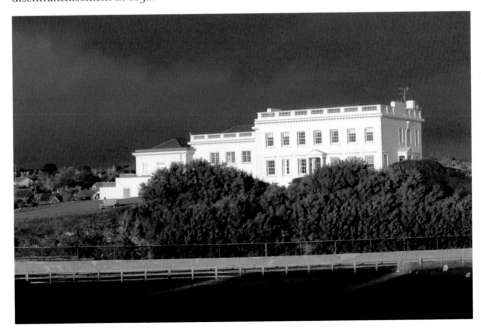

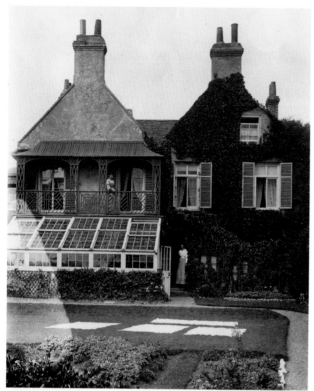

Saxon Lodge

This house was built in 1733 for the Beane family. Thomas Beane was a Bailiff of Seaford and Seaford Town Council still have measuring jugs stamped with his name. In 1882 Major Lewis Crook moved into the house and this picture possibly shows two of his daughters (he had nine children). Note the laundry left to dry on the grass. Today the house has been sympathetically restored to its former appearance.

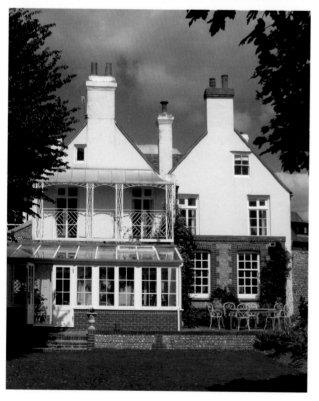

Place House

Place House was built for the Gratwicke family in 1603. When it was demolished in 1935, Amy Chambers, a member of Seaford Council and former Headmistress of Church Street School, purchased the building materials and had it re-built at the corner of Stafford Road and Avondale Road. The building is now called Norlington House.

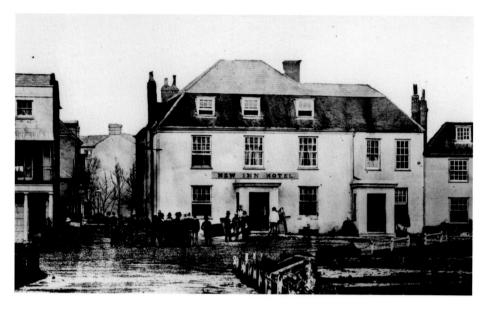

The Wellington

It is said that the Duke of Wellington stayed at the New Inn in Seaford on 6 October 1845. At this time he was Lord Warden of the Cinque Ports and was visiting the town to view coastal defences. A pub has stood here for over 250 years and the view above dates from 1875 shortly after the great flood.

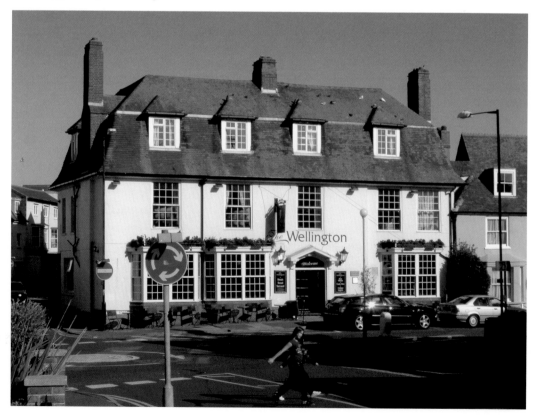

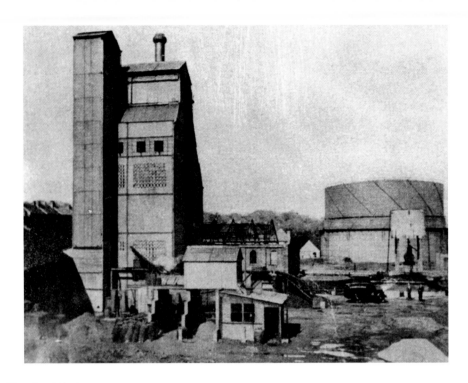

The Gas Works

Thomas Crook of Telsemaure (see page 28) established the Gas Works in Blatchington Road in the mid 1870s. In the 1920s the works were rebuilt and a gasholder was erected on the corner of Chichester Road. These two structures dominated the town for many years and the view above is dated 1928. Built in 1973, the popular Trek nightclub is now situated at this site.

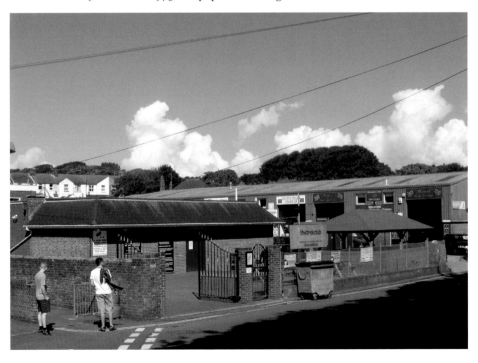

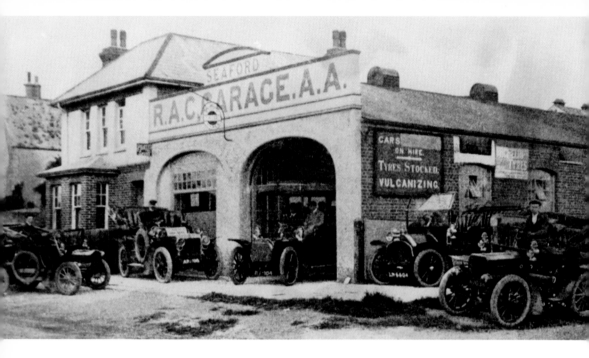

Steyne Road Garage

This was once part of the French's Garage. Mr French established a motor garage in Newhaven in 1896, the year of the first London to Brighton run. Benjamin French lived in Lucknow House, Church Street and first started selling petrol here in 1904. By 1906 the garage was being run as the Seaford Motor Engineering Works by Mr J. Martin.

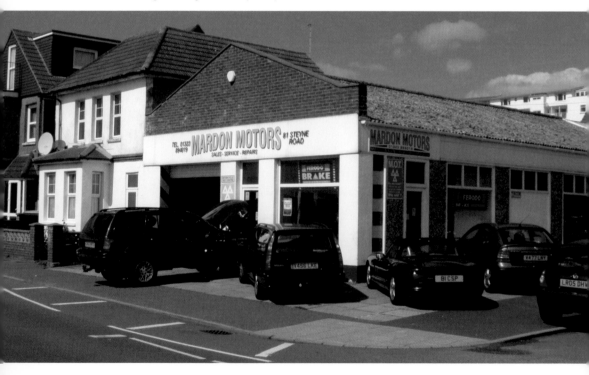

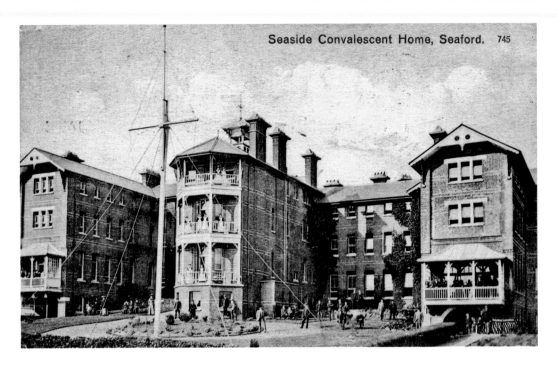

Seaside Convalescent Home

This purpose built home near the Crouch was built in 1873 to replace a building that had been established in the High Street in 1860 and was believed to be one of the first convalescent homes in the country. In 1922 a new wing with thirty extra beds was added. The building was replaced in 1964 by the Bramber Close development.

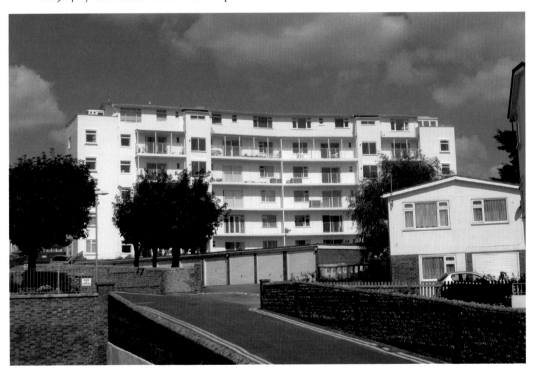

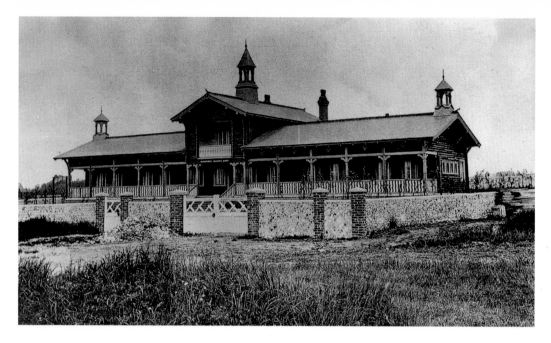

Bainbridge Home

Emerson Muschamp Bainbridge was a colliery owner from Newcastle. He was a Methodist, and the Chairman of the Federation of Free Churches. He was also extremely wealthy. In 1900 he purchased a building which had been the Swiss Pavilion at the Paris Exhibition. It was dismantled and rebuilt in Seaford as a holiday home for factory girls. The home was demolished in 1966 and today Bainbridge Close, off Heathfield Road stands on the site.

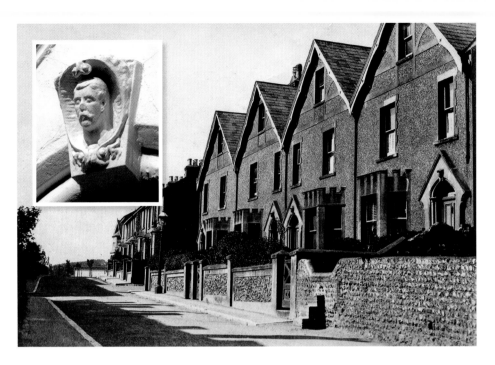

East Street

Each house in this row of four Victorian Terrace houses in East Street has a small bust of a moustachioed man above the door. The man looks like General Charles George Gordon (Gordon of Khartoum) and indeed as a child he used to visit East Street where his aunt, Maria Wallinger, lived at Crouch House just a few steps away.

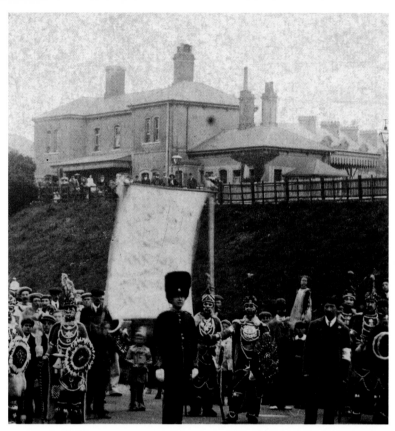

Railway Station

The railway came late to Seaford. The Seaford Improvement Company campaigned for the railway to be extended from Newhaven and the line eventually opened on 1 June 1864. Although Seaford Station has hardly changed, the roads around have. This view from 1919 shows a Hospital Parade in Claremont Road close to where the back of Flowers Furniture Store is now situated.

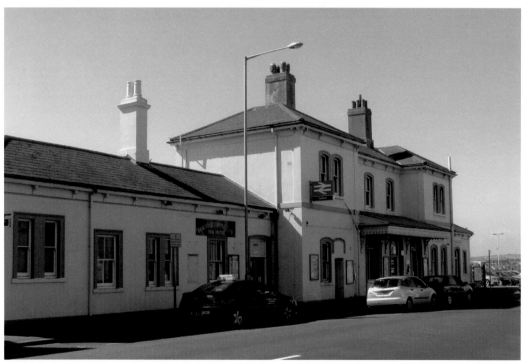

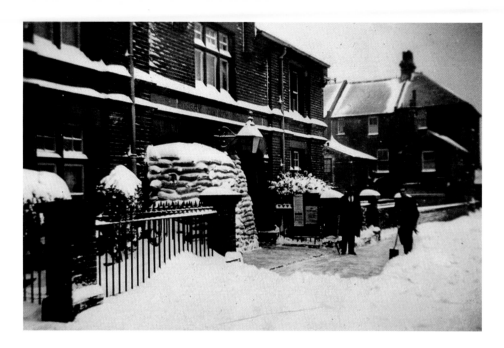

Police Station

Seaford's first Police Station was a thatched cottage in the High Street, but in 1896 a new building was opened in Chichester Road (above). This in turn was replaced in 1969 by a purpose built police station in Church Street. In 2008 the police station at 37 Church Street was reopened to accommodate a Tourist Information Centre, Seaford Town Council and the Citizens Advice Bureau.

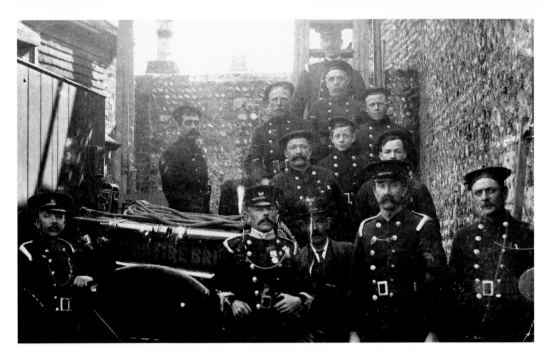

Fire Station

In 1877 a Mr Cullingford provided Seaford with the money to buy a fire engine, which was housed in the garden of Place House in Broad Street. Mr K. Woodhams was the first Captain and he is probably in the centre of this group. The Fire Station was later moved to South Street and during the Second World War was in Dane Road. A new Fire Station was built in Cradle Hill Road in 1969. Today it has a complement of eighteen retained firefighters.

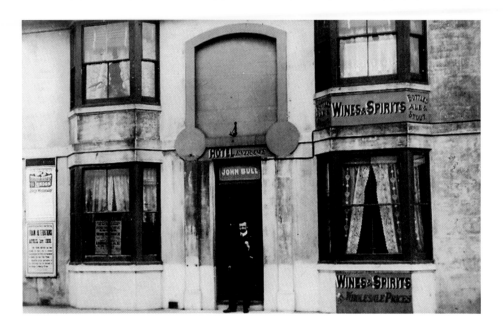

Terminus Hotel

Gloster Place, at the town end of Dane Road was built by William Tyler-Smith to coincide with the opening of the railway in 1864. The Terminus Hotel opened in July 1863 and was soon the HQ of the local Bonfire Society. It has now been re-branded 'The Shore' and is a regular venue during the SeafordLive! music festival.

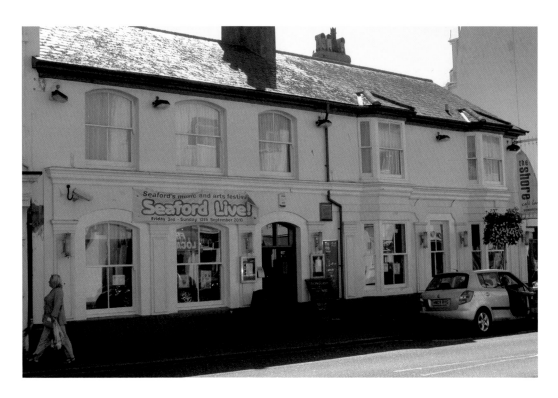

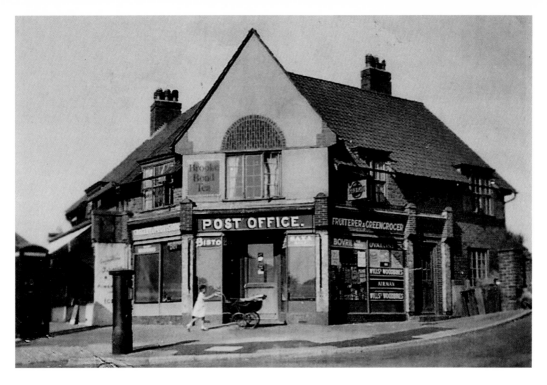

Vale Road Post Office
In 1937, Seaford Urban District Council decided to build seventy new houses in the Vale Road area of Seaford and a post office was opened in Kay's General Store on the corner of Sutton Drove. The post office was closed in 2005.

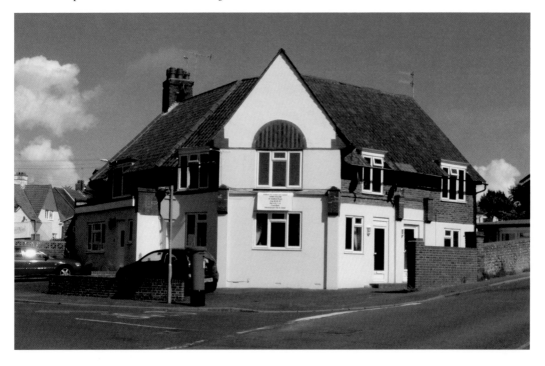

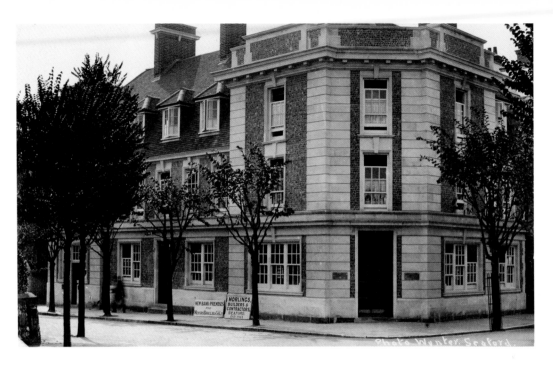

Barclays Bank
The bank buildings on the corner of Clinton Place and Broad Street were opened as the Lewes Old Bank and were built by Morlings, a local company based in Blatchington Road. The Manager occupied a house next door. Barclays Bank now occupies the building.

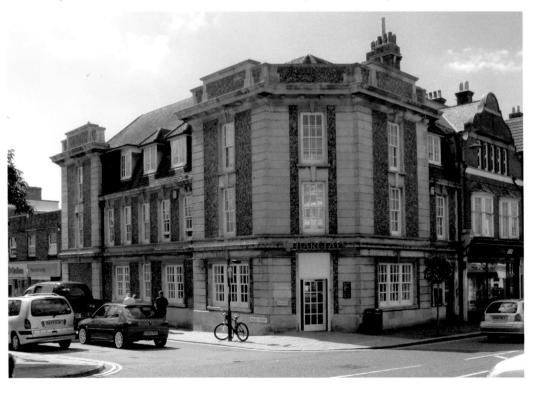

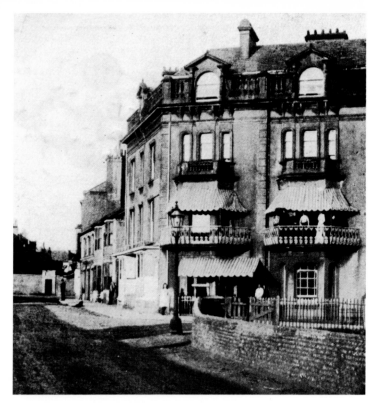

Eversley Hotel
Clementine Hozier attended the Gateway Kindergarten as a child. In 1908 she married Winston Churchill and a road in Seaford is now named after her. The picture above shows the building when it was the Eversley Hotel but it is now occupied by Lloyds Bank.

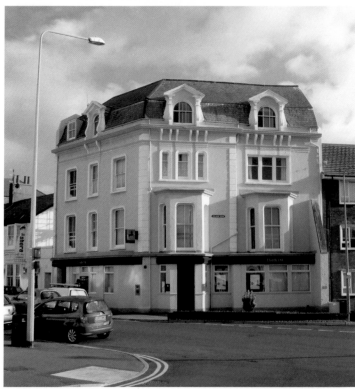

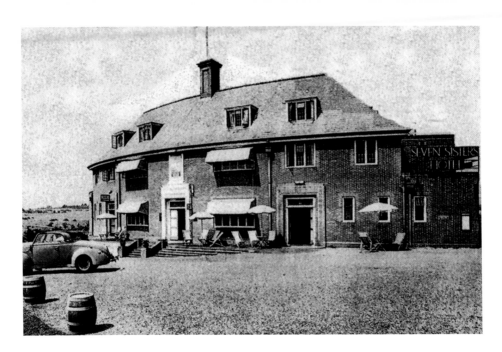

Seven Sisters Pub

Originally this pub was planned to be on the site of the ring road around Seaford. The Seven Sisters Hotel (known to locals as 'The Sevens') was built in 1932 for United Breweries by the Ringmer Building Works, but the road never materialised. It is still a popular pub and the HQ of several local societies.

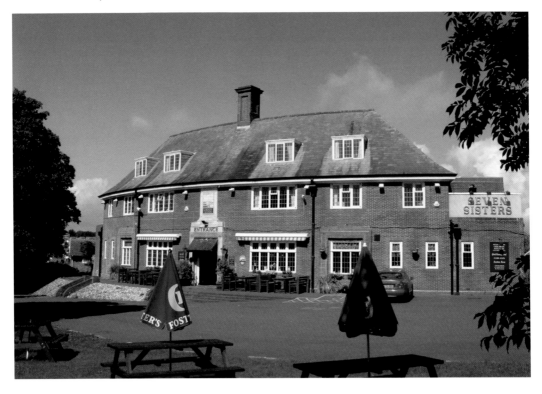

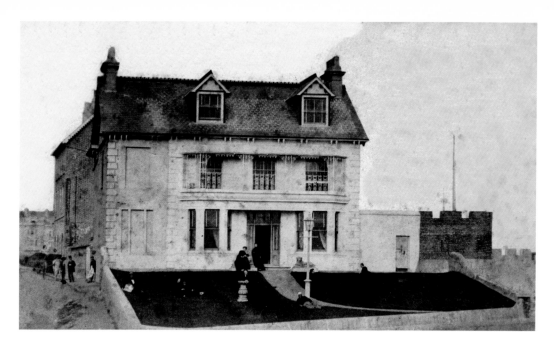

Telsemaure

The foundation stone for this grand house on the seafront was laid in autumn 1861. It was built for the influential Crook family and had eight bedrooms, four reception rooms, two bathrooms, a playroom and even a museum! The Crooks left in 1901 and it saw service as a hotel before being demolished in March 1937.

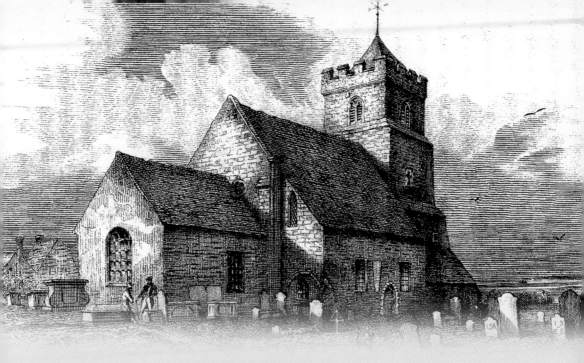

CHAPTER 2

Churches

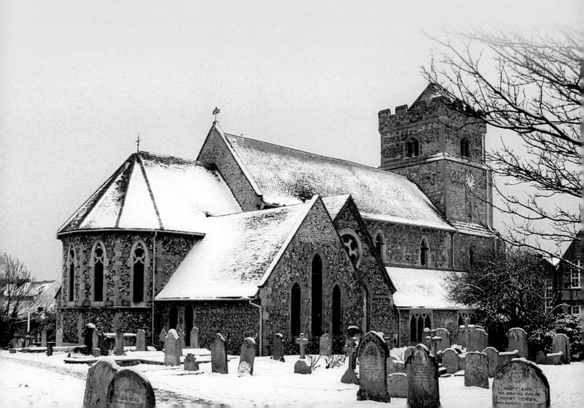

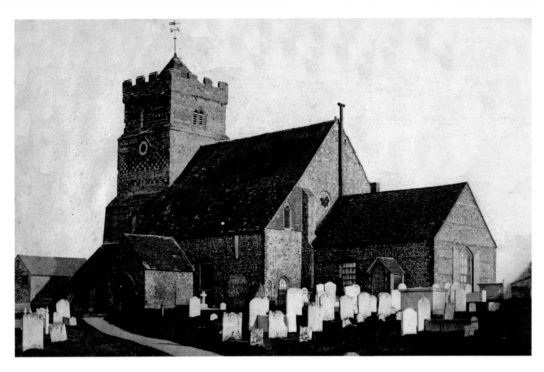

St Leonard's Parish Church
Parts of the church date from the eleventh century and the sturdy tower was built about 1485. This view shows the church prior to the major Victorian 'restorations' of 1863 when the porch and the eastern end of the church were completely rebuilt.

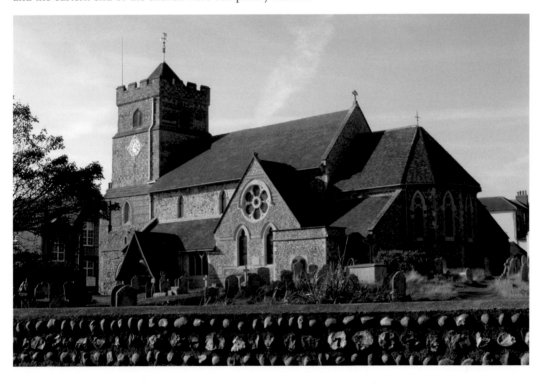

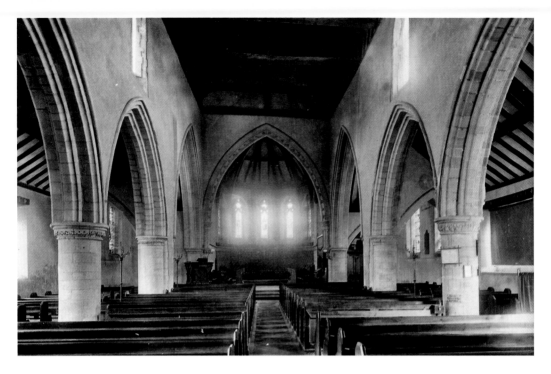

Church Interior 1891

Visitors to the church can see beautiful thirteenth-century carvings of St Michael and scenes from the bible, including the Crucifixion. One of the chancel windows is dedicated to Felton Mathew who negotiated with Maoris to buy the land on which the capital of New Zealand, Auckland is now situated.

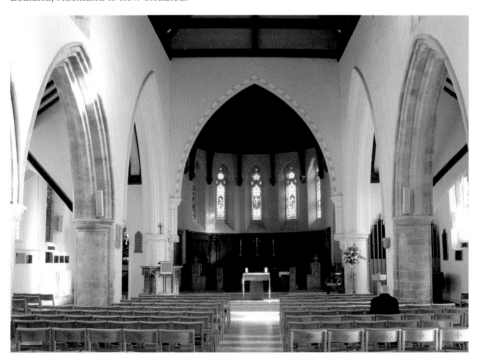

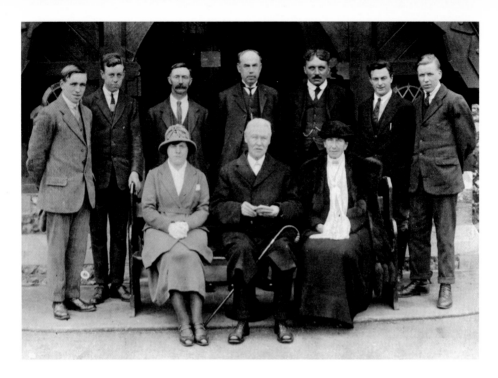

Bellringers

The original bells for St Lawrence's Church were probably cast by John Waylett, an itinerate bell founder in 1724. The bells were re-cast by Mears of Whitechapel in 1811 and received their first full ring (a peal of 5,040 changes) on 27 December that year. Today the bells are still rung for church services.

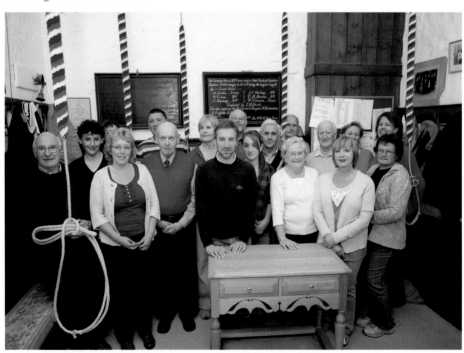

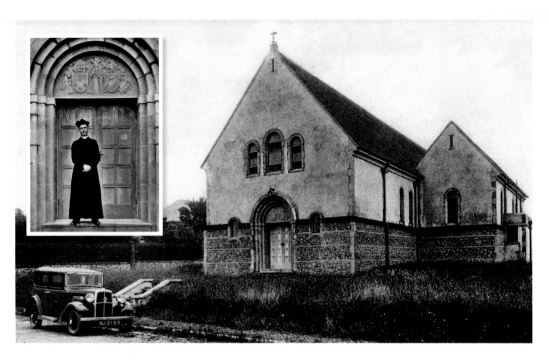

St Thomas More

Catholic worship took place at various locations around the town but in June 1935 the foundation stone was laid for a new church. It was named St Thomas More after the Tudor statesman who had been canonised just a month earlier. The first parish priest was Father Reginald Webb (inset) who took the first service at the new church on 12 March 1936.

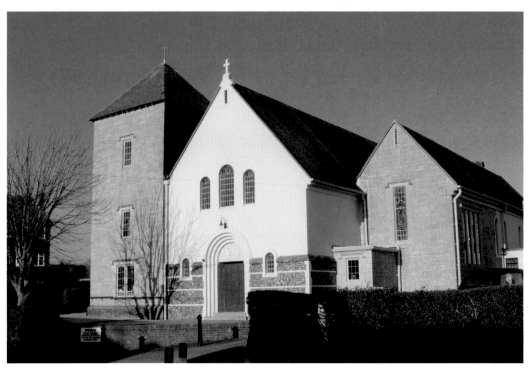

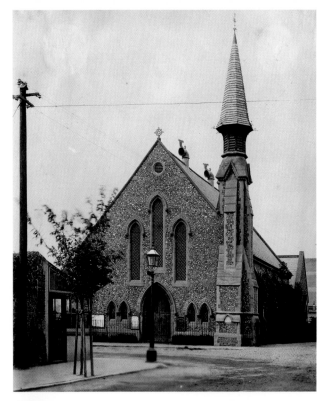

Congregational Church
In 1877 the English Congregational Chapel Building Society agreed to fund the building of a new church in Seaford and the foundation stone was laid by Mrs Crook of Telsemaure (see page 28) that December. The architectural historian Nikolaus Pevsner described the tower as being 'daring and funny' and it had to be replaced when it was seen swaying in a storm in 1990. More recently used for worship by the United Reform Church, the building is now part of the Cross Way Centre and is the scene of many community events.

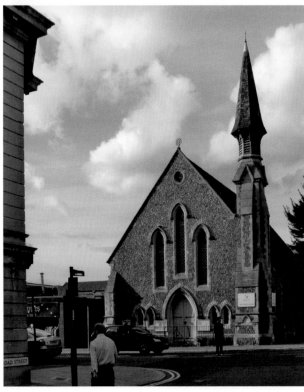

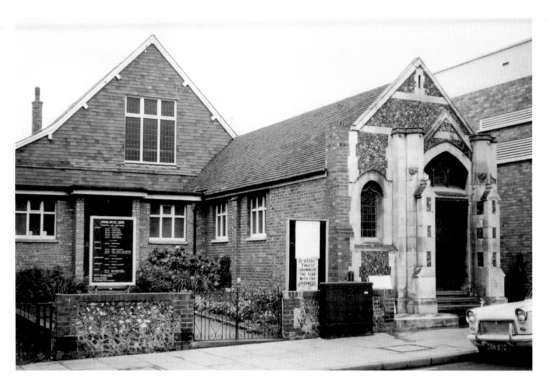

Baptist Church

The Baptist Church originally was situated in the High Street but moved to Broad Street in 1908. In 1972 it was demolished and WH Smith now occupies the site. A bold new Baptist Church was built in Belgrave Road in 1973.

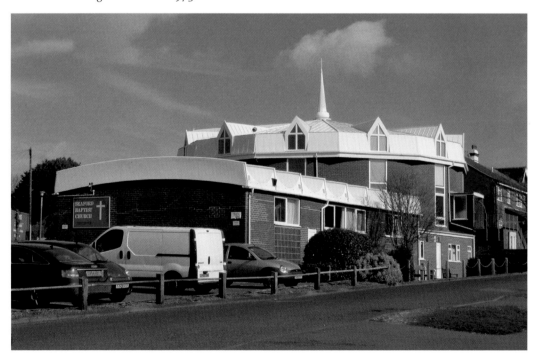

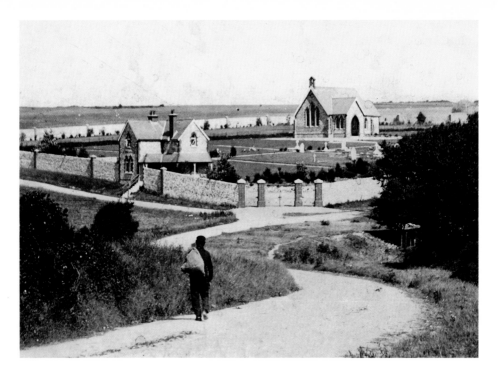

Cemetery

Seaford Cemetery on the Alfriston Road was laid out and the caretaker's lodge was built in 1896, although the first burial was not until 6 March 1897. The chapel was built the following year. With 273 Commonwealth war graves, Seaford Cemetery is one of the largest war graves in Sussex. Many graves are of Canadians and West Indians who died during the First World War.

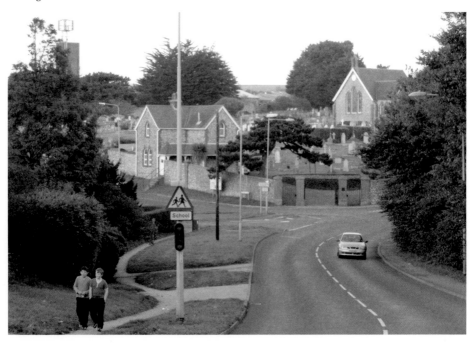

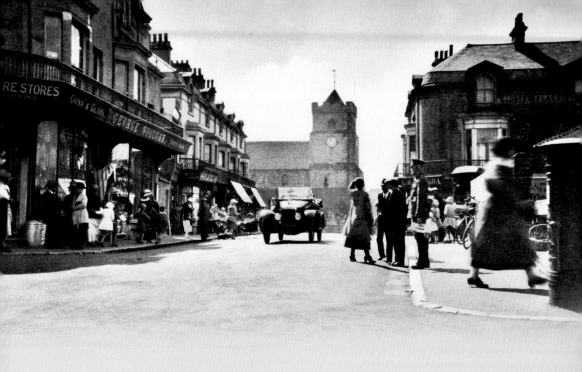

CHAPTER 3

Streets

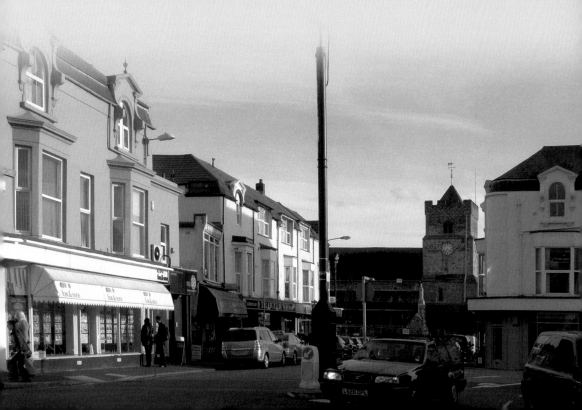

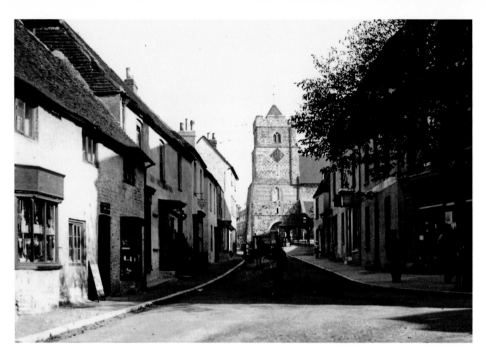

Church Street

Church Street runs between the old port of Seaford and its parish church. During the Hundred Years' War, French raiders would have charged up this street to burn down the parish church, but today the French are welcomed in the town and the road is regularly closed so that a popular French Market can set up.

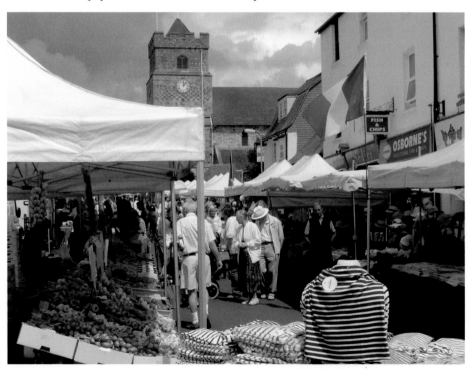

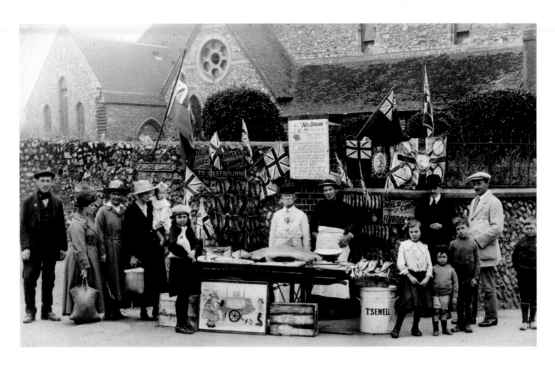

Place Lane

It is 1919 and patriotic fishmonger T. Sewell of Brighton has set up his stall in Place Lane selling a variety of shellfish as well as fresh and cured fish. Today Paul's Plaice, just a few feet away in Dane Road, provides an excellent and tasty variety of locally caught fish.

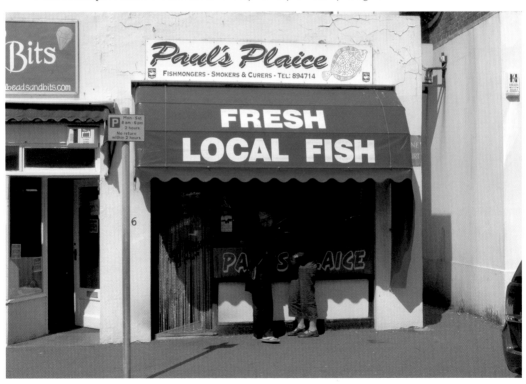

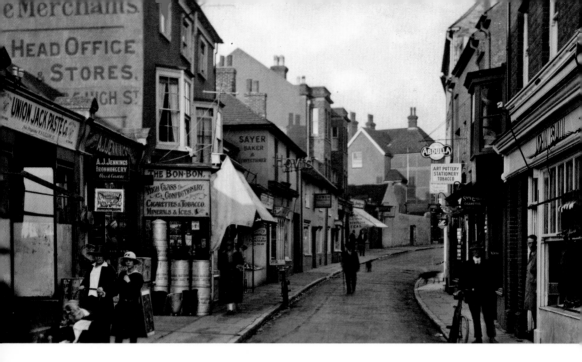

Lower High Street

On the right is the shop of John Bull who sold fish and game. This was later to become MacFisheries. On the left the Union Jack Paste Company sold corn plasters which were made in Brooklyn Road but sold throughout the empire. Further up, a 'Hovis' sign marks Sayer's Bakery. This is now the Old Boot Inn.

Upper High Street
These ancient cottages included a watchmaker and a hairdresser's (marked by the striped pole). The cottages to the right were demolished in 1899 to make way for a bank and the post office. These premises are now occupied by Toy Town, a toyshop established in 2009 by local optician Daeron McGee.

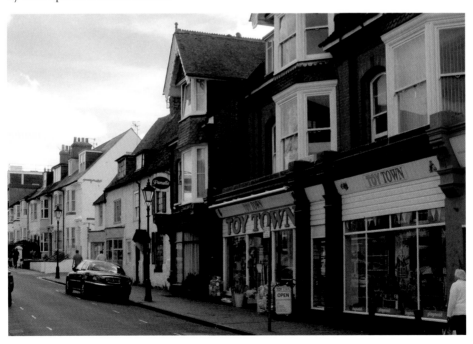

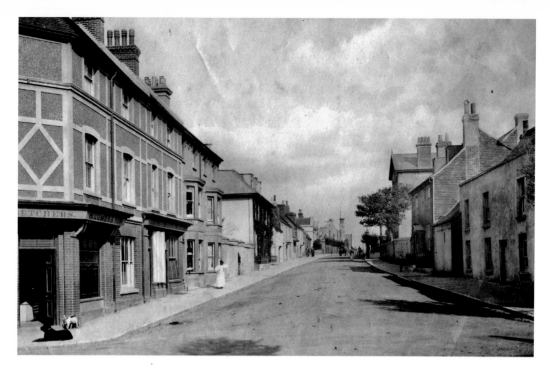

Broad Street

A butcher has occupied the premises on the corner of Broad Street and the High Street for over 100 years and when this view was taken it was run by Harry Combs. Apart from the optimistic dogs waiting outside the butcher's and a well-dressed lady hurrying along, the road is relatively empty of people and traffic. Today the road has become the busiest shopping street in town.

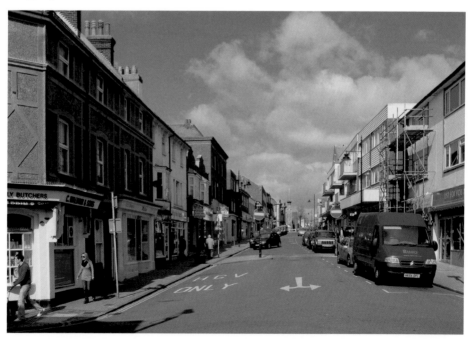

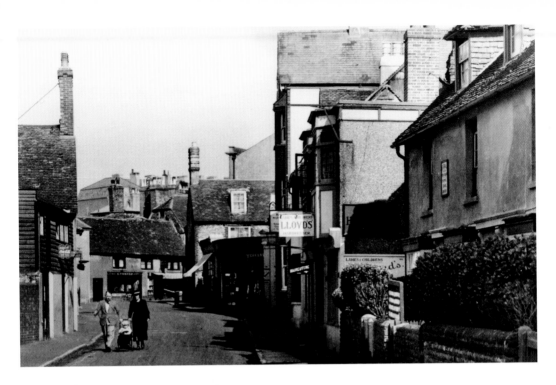

South Street

The old harbour of Seaford used to be in the foreground of this picture. The stone monument in the lower view is now a sundial but was previously the Jubilee Fountain that had been erected outside the New Inn to commemorate Queen Victoria's Jubilee of 1887. Prior to that it was the base of a swivel-gun in the Seaford battery, a small fort on the Esplanade.

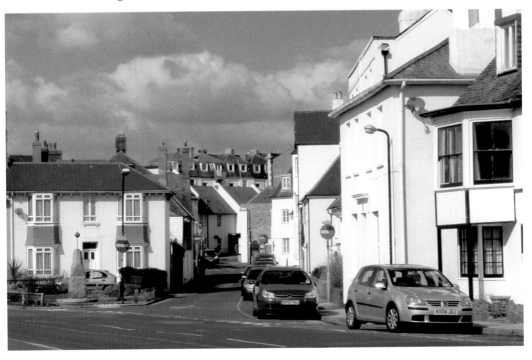

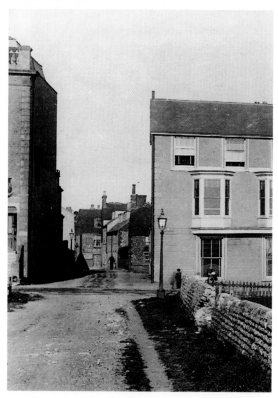

West Street

Looking across Pelham Road towards Church Street, this view shows the Bay Tree Inn on the left. This pub was built in 1874 as the Bay Hotel and was for many years the clubhouse for Seaford Head Golf Course (see page 90). The proprietor Louis Holzinger gave preferential rates for golfers. It was one of the first premises to have a telephone fitted and had the number Seaford 2.

Dane Road

This track was named Dane Road after the River Dann which used to run into the sea nearby. The early view shows the road as just a track with Pelham Terrace in the distance. The black and white stripes on the wall in the modern picture are 'black out' markings dating from the Second World War.

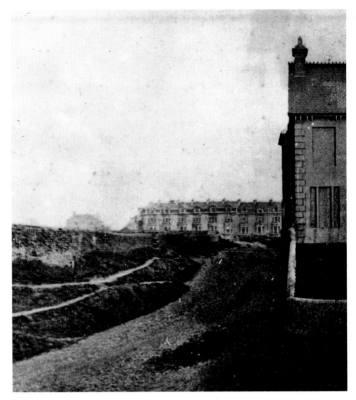

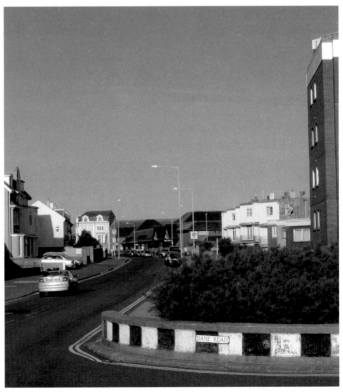

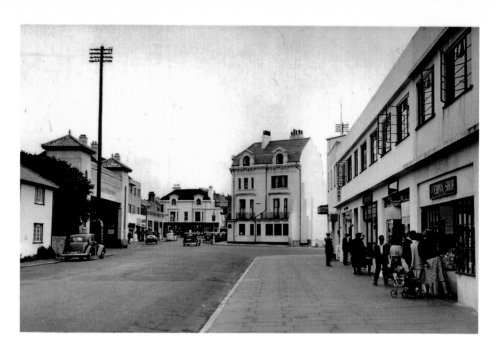

Dane Road

In July 1986 a Safeway supermarket (now Morrison's) replaced the Ritz cinema which can be seen on the right. The view from the 1950s shows the Southdown bus garage on the left. Lloyds Bank (see page 26) is central to both pictures.

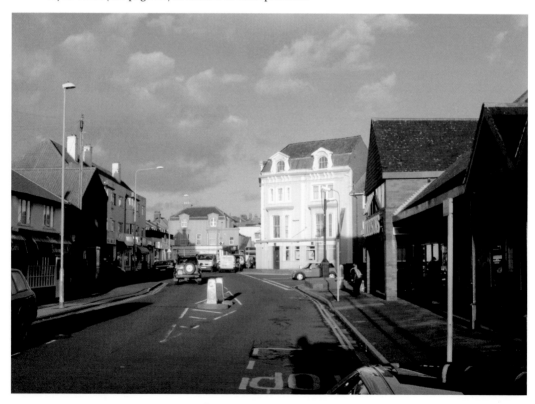

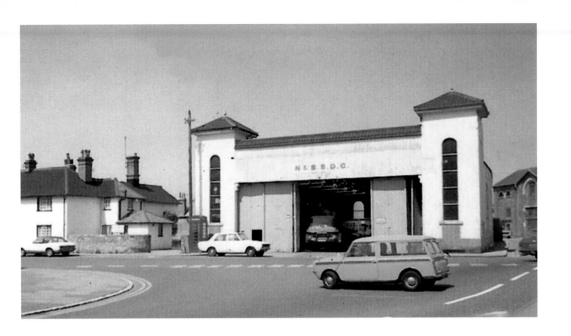

Health Centre

The Southdown bus garage seen in the previous view is now occupied by the depot of the Newhaven & Seaford Sea Defence Commissioners. This was replaced in 1986 by the Seaford Health Centre. Note how the red telephone box has been replaced by a new one. Pelham Cottage on the left is now the popular Diella's Restaurant.

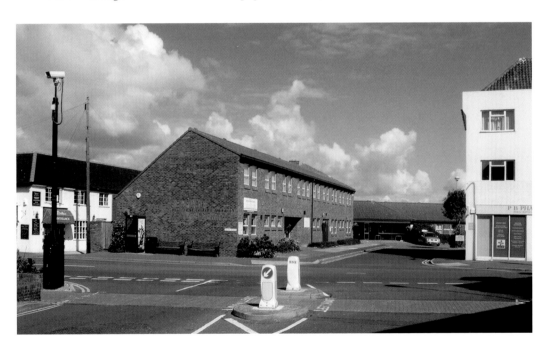

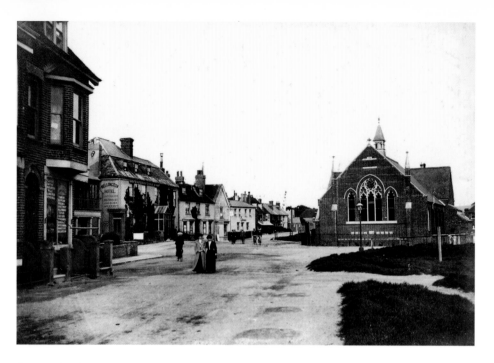

Steyne Road

Steyne is an old word for stone and probably relates to an old sea defence. The Methodist Church on the right was built in 1894 and is now the Cross Way Centre. Marine Terrace and The Wellington Inn are on the left. Unlike today, 100 years ago Seafordians could walk unhindered down the middle of the road.

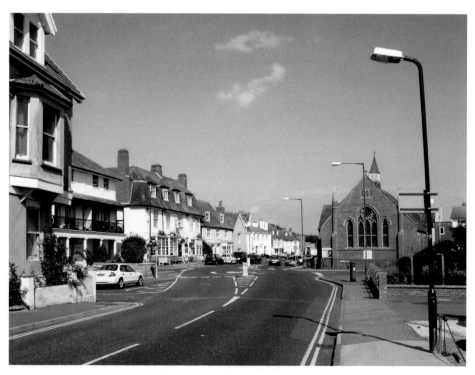

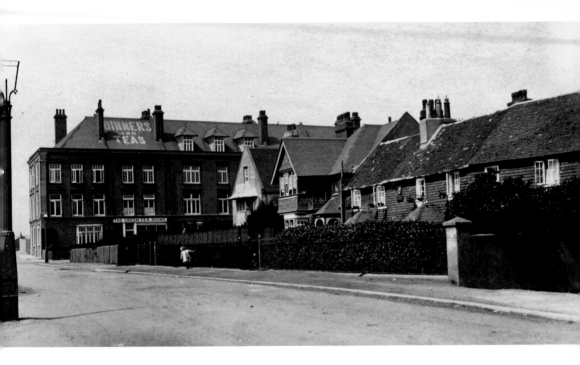

Parliament Row

These squat eighteenth-century tile hung cottages are called Parliament Row and recall the parliamentary shenanigans that went on when Seaford was a rotten or pocket borough. Seaford returned two MPs from 1298 until the Reform Act of 1832. Three of these MPs were Prime Ministers.

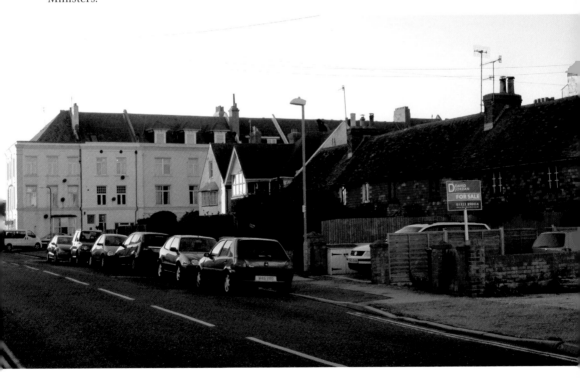

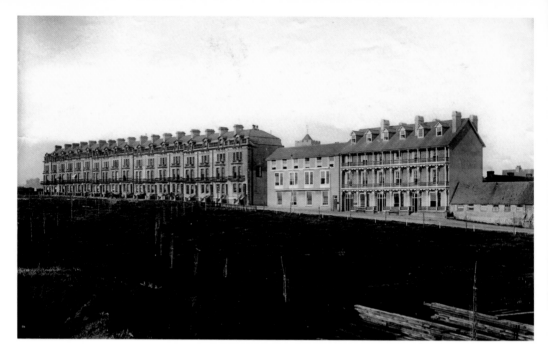

Pelham Road

This road was named after the Pelham Family (Dukes of Newcastle) who lived at Bishopstone Place and were local landowners. The fine terrace of houses was built by William Tyler Smith in the 1850s. The western end (opposite Morrisons) was destroyed in an air raid in November 1942 and was unsympathetically re-built in 1961 as Welbeck Court, seen on the left in the lower view.

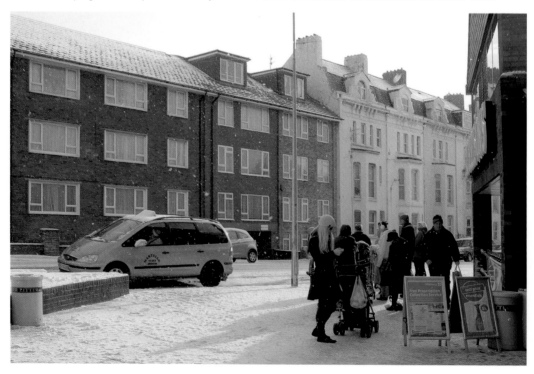

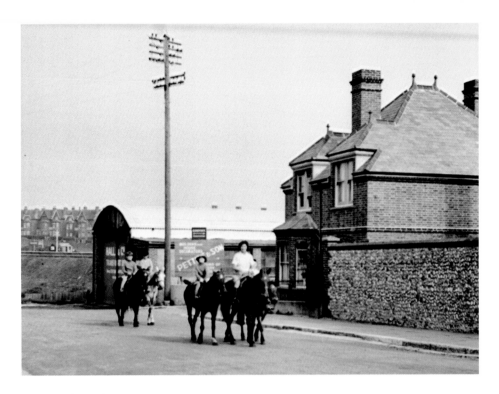

Richmond Road

Richmond Road is named after the Duke of Richmond who was the Bailiff of Seaford for a short time and was presented with the freedom of the town in 1789. Today the road leads to the Salts Recreation Ground and a council car park but it once was also the site of a livery stables. The photograph shows members of the Ball family who ran the stables in the 1950s.

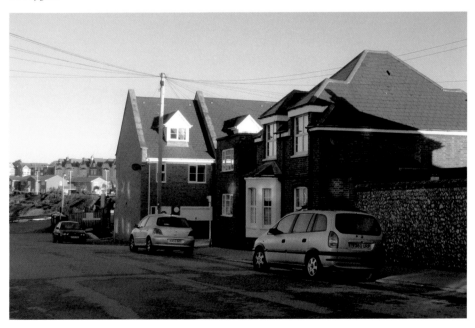

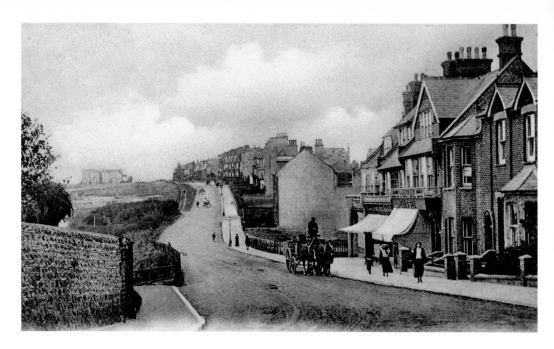

Claremont Road

Claremont is a house in Surrey once owned by the Pelham family, who were the local landowners in the eighteenth century. The road was laid out in 1879 and, until 1929, when the station approach was adopted, it was the main road through the town. The headquarters of the Seaford Women's Institute, one of the first in the country, is in the centre of the pictures and was built in 1916.

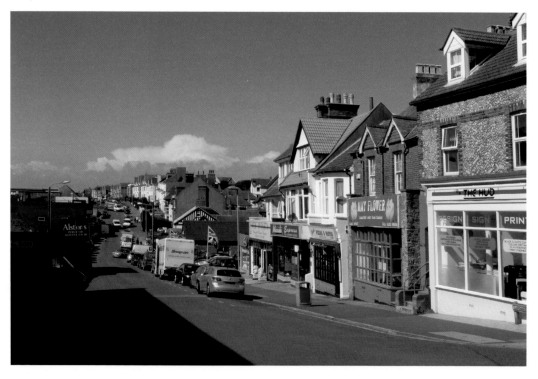

Crouch Lane

Crouch is probably a corruption of 'cross' as this was the site of Seaford's medieval market which would have once had a market cross. On the right is Stone's House (see page 5) and beyond can be seen Seaford House which was the home of Alfred, Lord Tennyson for a few months in 1852. The Martello Tower can be seen in the distance.

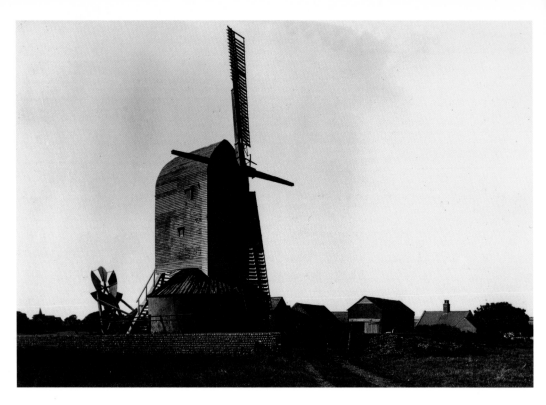

Sutton Mill

This post mill was *in situ* in the sixteenth century. The last miller was Thomas Sayer who ran the mill from 1887 until 1900 when it closed. Prior to the mill being demolished in 1904, the following two photographs were taken from the top. Below is the view along Southdown Road towards Seaford Head.

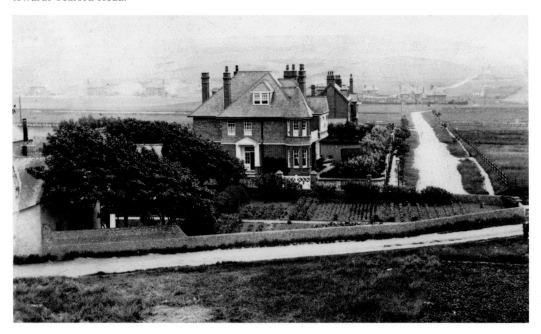

Hindover Road

In this view from the top of the windmill, allotments can be seen in the foreground. A track called Twittery Lane (now Mill Drive) cuts across the field to Hindover Road, named after the nearby hill which is also called High and Over.

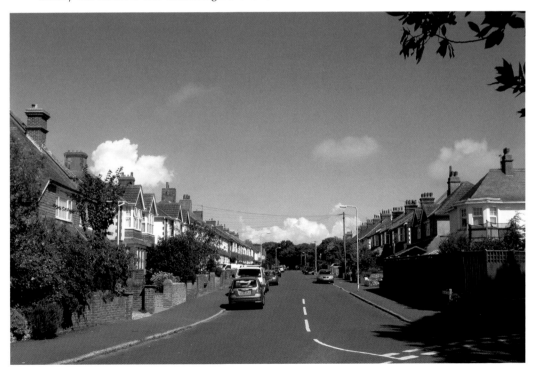

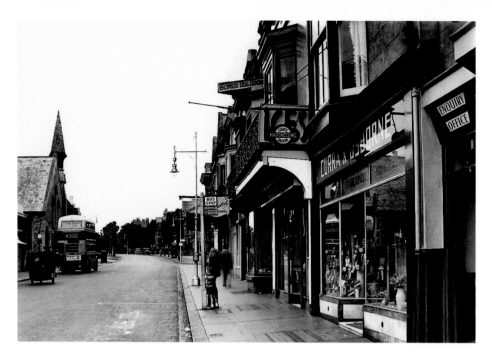

Clinton Place

The Clintons were an old English family. Henry Clinton, 8th Earl of Lincoln (1720-1794) became the second Duke of Newcastle on the death of his uncle and cousin. He took the name Henry Pelham-Clinton and was part of the family who owned large parts of Seaford. The Congregational Church can be seen is on the left along with the number 12 bus which still runs between Brighton and Eastbourne via Seaford.

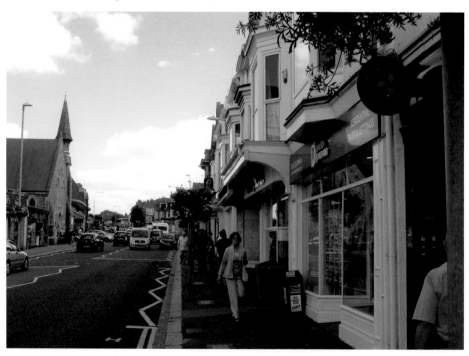

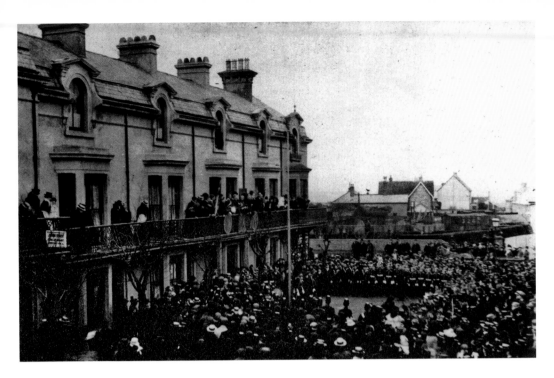

Seaford Urban District Council

The Council had its first meeting at 3 Clinton Place in 1895 as the old Town Hall (page 9) was too small. On 28 January 1901 the proclamation of the Accession of Edward VII was read from the Council Offices and as you can see, a large crowd attended. Goods trucks can be seen at the railway station in the top right of the view.

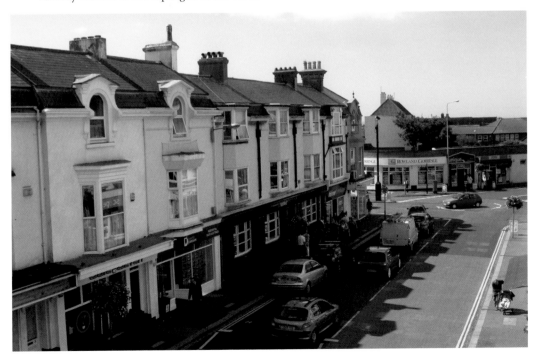

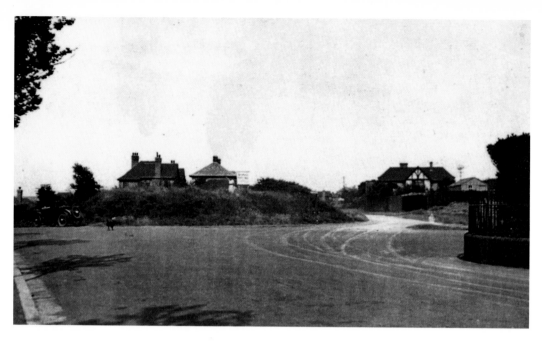

Sutton Park Road

This part of the main road towards Eastbourne was know as the 'Cat's Cemetery' until the war memorial was moved here from a site in Dane Road in 1952. On the left is Avondale Road which was laid out in about 1908 and named after Prince Albert Victor, Duke of Avondale and grandson of Queen Victoria. The war memorial and flagpole for Seaford Town Council are now sited here.

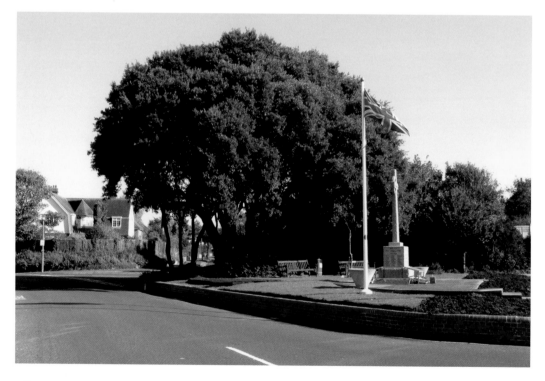

War Memorial

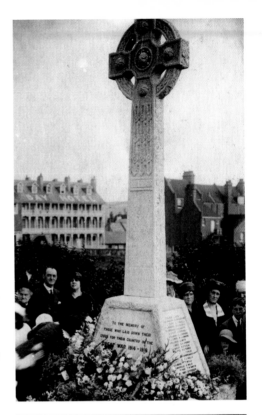

The Seaford branch of the Royal British
Legion was formed on 2 August 1921 and the
very next day the members gathered at a site
in Green Lane off Dane Road to witness the
unveiling of their new war memorial. This was
in the shape of a Celtic cross made of Cornish
granite. The first 'Poppy Day' was also held
that year. After the Second World War further
names were added including those Seafordians
killed in air raids. In 1952 it was decided to
move the memorial to a more visible site in
Sutton Park Road.

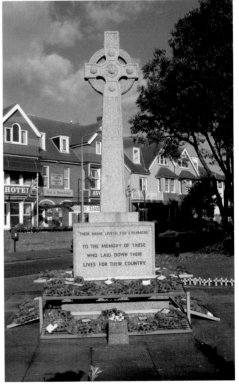

Blatchington Pond

This view of the pond shows the junction of Sutton Drove and Avondale Road. The pond was first mentioned in parish records in 1645. In December 1913 Seaford Council bought the pond for £10 and in 1980 a conservation society was established to care for it.

Sutton Corner

This area was originally a separate village with its own church but it merged with the parish of Seaford in 1534. Bimbo's garage run by Mr T. W. Barfoot was situated here. The entrance to Sutton Place (now part of Newlands School) is on the right. A roundabout was built at the junction of Alfriston Road in August 2010.

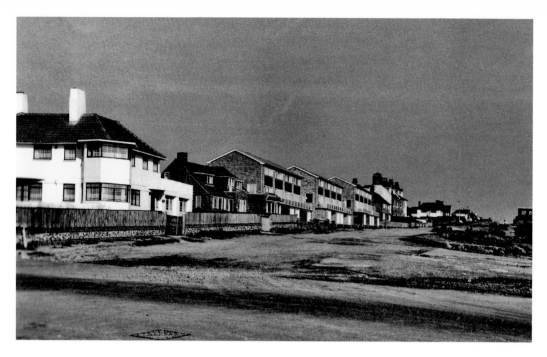

Edinburgh Road

Edinburgh Road is a part of the Queen's Park Estate where all the roads were to be named after Queen Victoria's family. The Queen's second son was Prince Alfred, the Duke of Edinburgh. The road was not metalled until the 1960s. The large white house to the left of the older view is 'Down Channel' which was demolished in 1987.

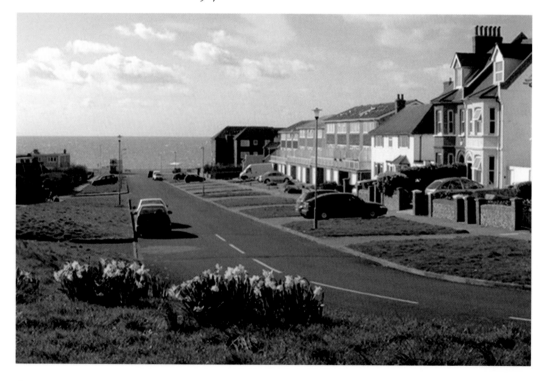

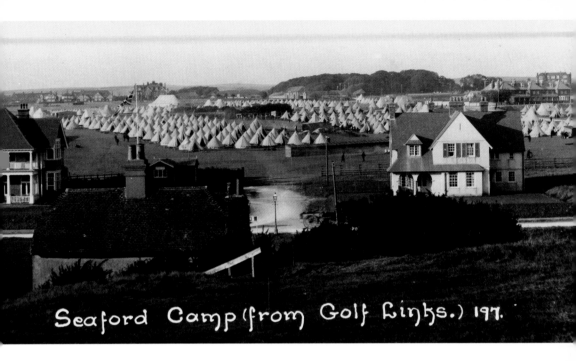

Seaford Camp (from Golf Links.) 197.

Chyngton Road

'Kitcheners Camp' was established to the west of Chyngton Road in 1914. Also known as the South Camp or Chyngton Camp, the tents were soon replaced by wooden huts which included a cinema and large YMCA hut. A fire here in October 1914 was blamed on 'foreign looking spies'.

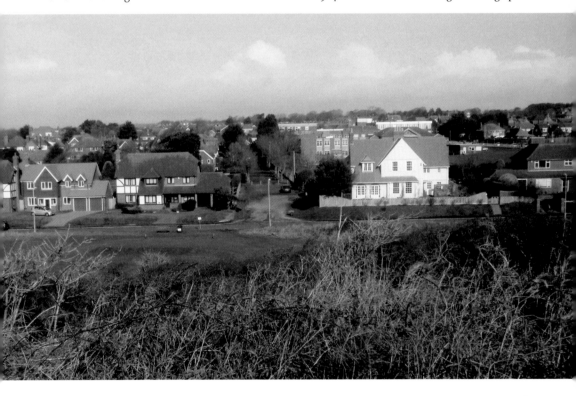

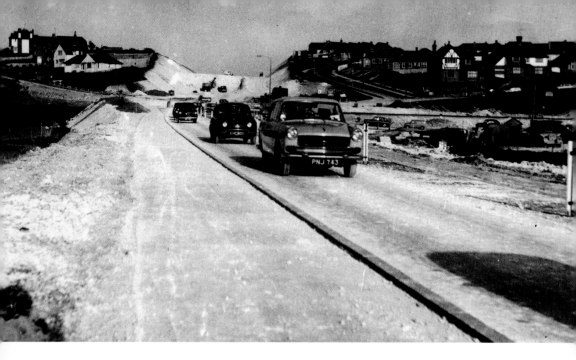

Buckle By-Pass

The Buckle by-pass was cut through Hawth Hill (hawth is another word for furze or heather). It was opened in 1964 and cost £150,000 to construct. Prior to its opening, traffic had to pass under the Buckle railway bridge and along the seafront.

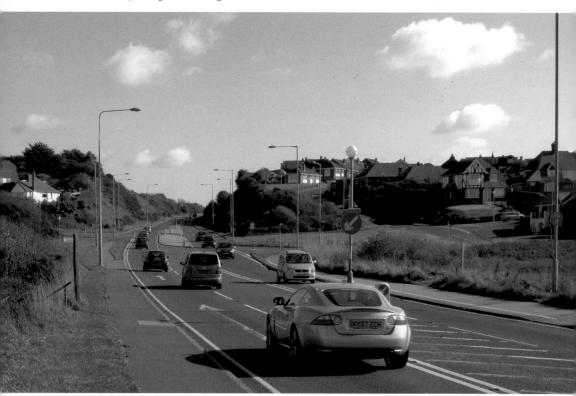

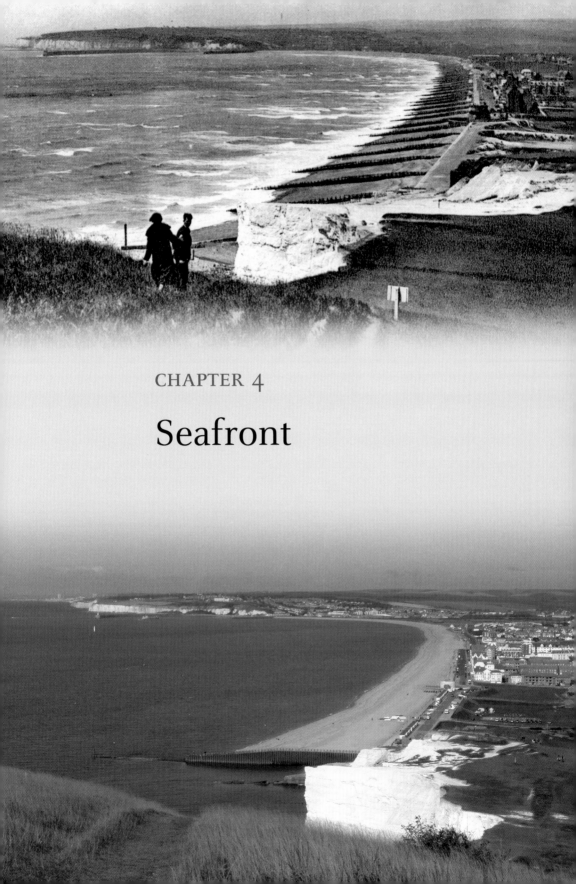

CHAPTER 4

Seafront

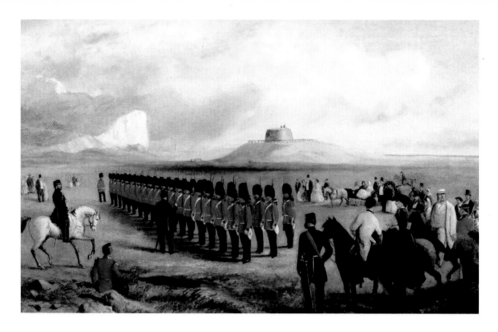

The Martello Tower

In 1805 General Twiss of the Royal Engineers visited Seaford and arranged for three Martello Towers to be built in the bay. Only one, Tower 74, was constructed and it was up and running by 1808. The picture above shows the Honourable Artillery Company parading nearby on the Martello Fields. In 1905 a letter to a local newspaper described the tower as a 'pimple on the face of nature' and there were calls to demolish it. The tower was purchased by local builder Tom Funnell in 1911 who turned it into a skating rink with tearooms.

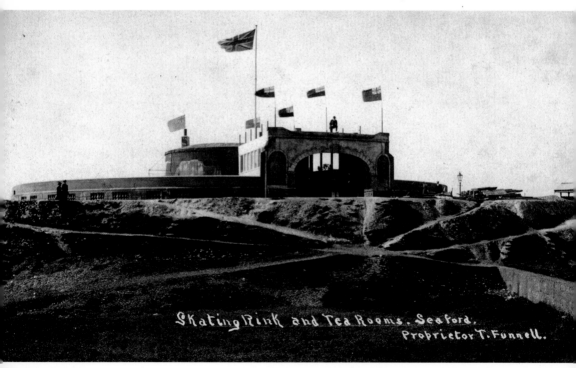

Skating Rink and Tea Rooms, Seaford. Proprietor T. Funnell.

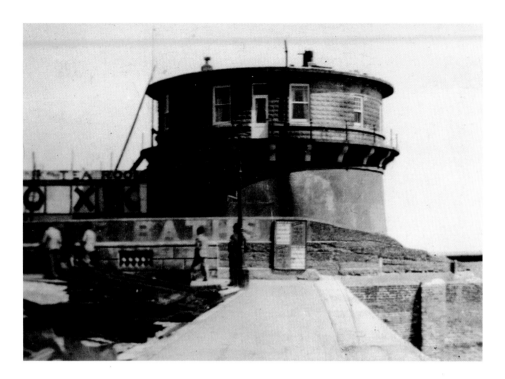

A Round House

Soon after he purchased the Martello Tower, Tom Funnell built a round house on the roof of the old fort and he moved in with his wife Helen. He cut doors through the thick walls of the tower and added a concrete staircase. As well as tearooms there were public baths and the tower could be viewed for an entrance fee of 2*d*. The flat was removed in 1968 and three years later the building was listed.

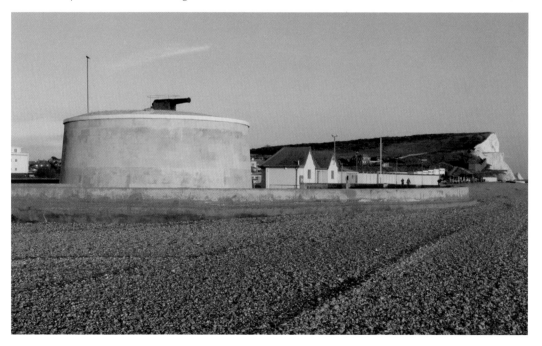

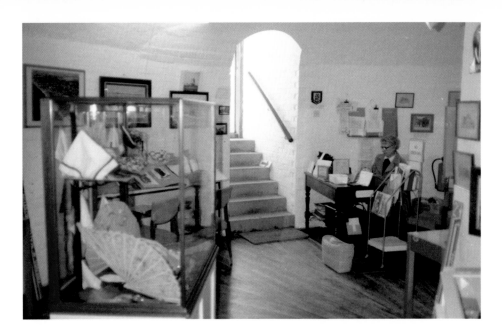

Seaford Museum

Seaford Museum was originally located in a caravan which toured local events. It later moved to West House (see page 8) but on 12 April 1979 opened at the Martello Tower. As there was plenty of space, a call went out for objects to put on display and the public responded with all manner of items. Today the museum has a vast and diverse collection of domestic objects from radios to washing machines as well as local, maritime and military history. In March 2010, Turner Prize winning potter Grayson Perry described the tower as his 'favourite museum in the whole world.'

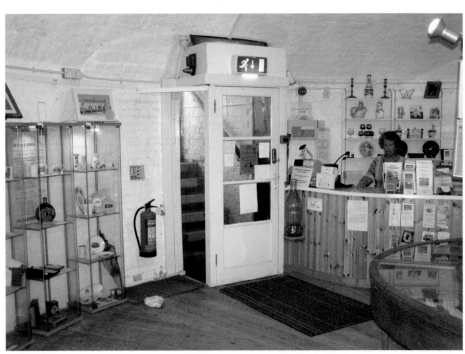

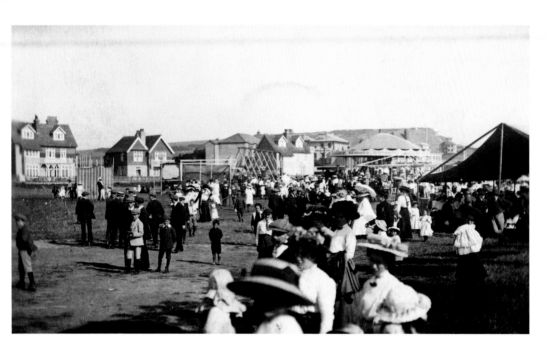

Martello Fields

The fields between the
Martello Tower and Steyne
Road were originally called
the Beame Lands and
hosted community events
such as the Summer Fair
(above) and the bonfire on
Guy Fawkes night. Today
they are called Martello
Fields and are managed by
Seaford Town Council. In
August 2009 a 'Bike Fest'
here attracted hundreds of
visitors.

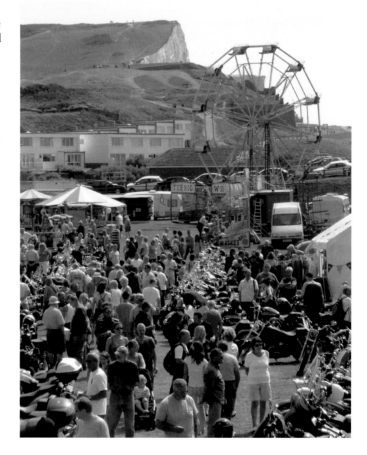

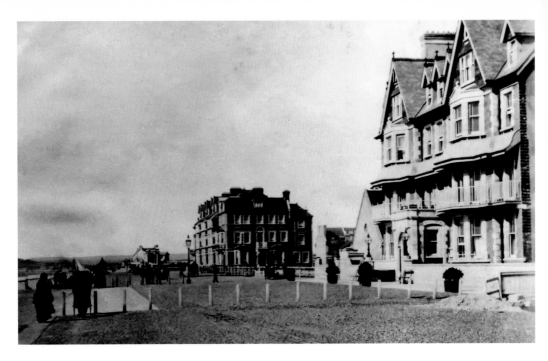

The Esplanade

The Esplanade Hotel on the right of the picture above, was built in 1891 on the site of the Assembly Rooms and Bath House (see page 11). In 1901 the manageress Mrs Hindle was killed when she fell down an open lift shaft and in 1905 famous visitors included The Duke and Duchess of Sparta (later King Constantine and Queen Sophie of Greece) and King Edward VII. In July 1976 the hotel was badly damaged by fire and later demolished. Since the beach reclamation works of 1987 the sea has literally been pushed back allowing for new properties to be built along the seafront.

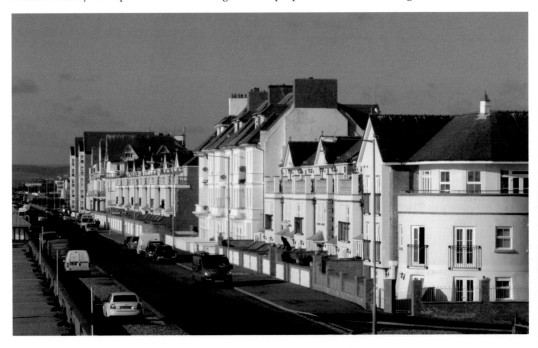

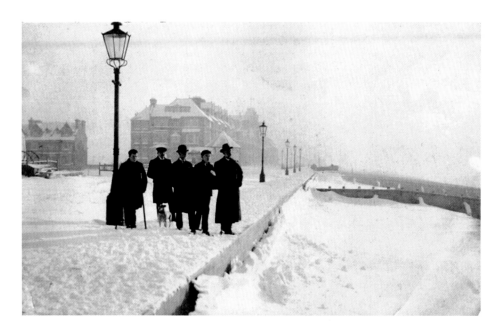

Snow and Ice

These scenes date from 1911 and 2010 when it was so cold that in some places the sea froze. On several occasions heavy snowfall has blocked the railway line between Seaford and Newhaven and at 6.30pm on 31 March 1897, hailstones the size of small oranges fell on the town causing extensive damage, with over 3,000 panes of glass being smashed. Nine hailstones were found to weigh ¾ lb and photographs of them appeared in the national press.

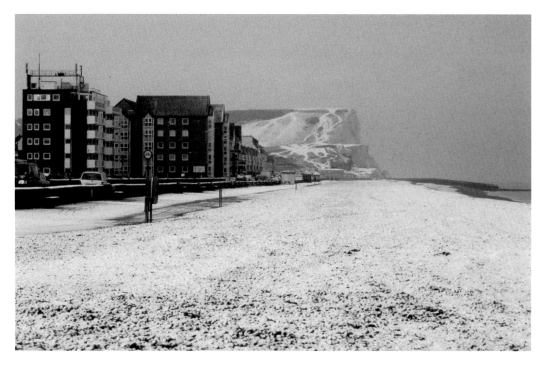

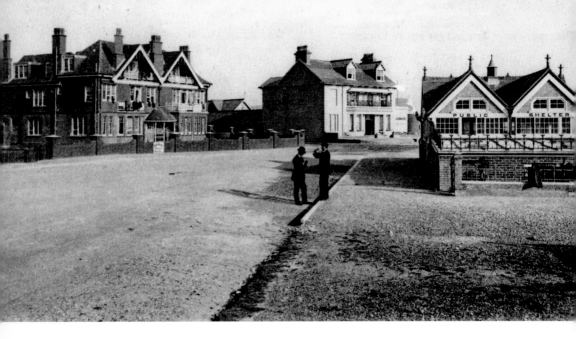

Eversley Hotel
This view dates from the 1920s when the Eversley Hotel had moved from Dane Road to the seafront. This building is now the Beachcomber pub but is threatened with redevelopment. In the centre of the upper view is the Telsemaure Hotel and to the right a shelter which included public conveniences. The flagpole on the modern picture is used by the Seaford Lifeguards for beach warning flags.

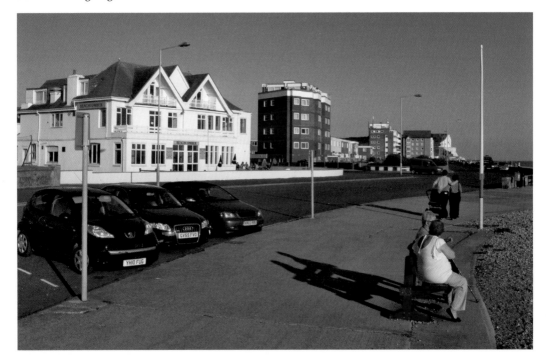

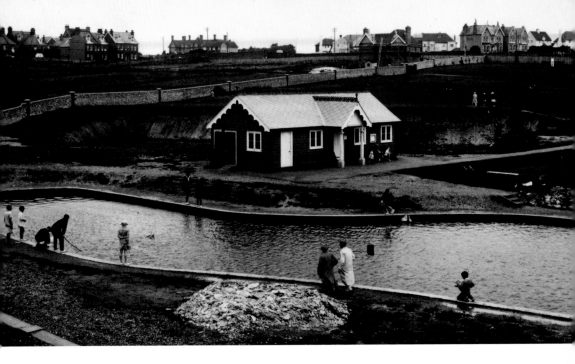

The Salts

This public area adjacent to the seafront was purchased by Seaford Council in December 1913 for a cost of £1,050. Sunday sports were banned at the ground until a public referendum overturned the decision in 1930. There was a large boating lake and deckchairs could be hired for 2*d* an hour. Today the Salts hosts cricket and rugby matches and there are tennis courts, a mini golf course and skate ramp. A popular café provides refreshments.

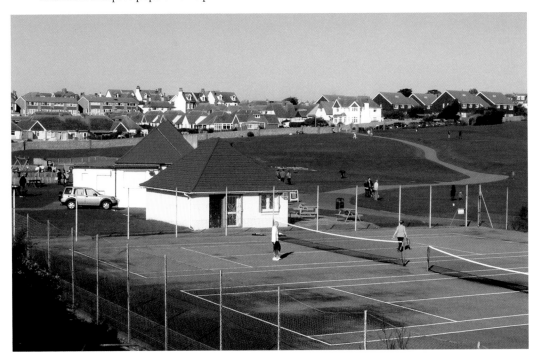

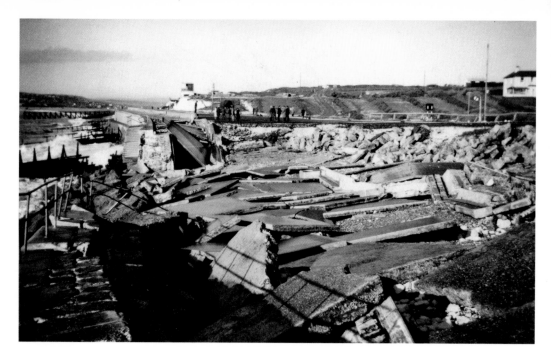

Seafront Damage

For hundreds of years Seaford Bay has received the full force of the sea and in the past the Esplanade was regularly breached. In 1875 the 'Great Storm' saw sea water lapping around the walls of St Leonard's Church. The view above from the early 1960s shows the force of the sea. Such scenes came to an end in 1987 when the beach was built up in a multi-million pound scheme. The beach is now used for a variety of events such as marathons and fun runs.

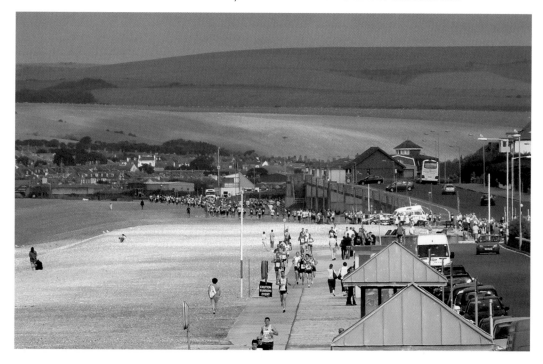

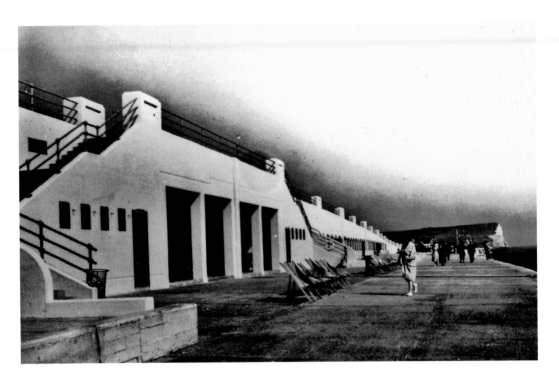

Bonningstedt Promenade

This section of Marine Parade once boasted a café, public conveniences and beach chalets set back into the concrete parade. These amenities were regularly damaged by the sea and closed. Since the 1980s there has been regular contact with Bonningstedt, a small German town north of Hamburg and a formal twinning agreement was signed in 1984. Twinning signs were erected both in Seaford and in Bonningstedt and in 1993 this area of the seafront was renamed Bonningstedt Promenade. The Seaford Twinning Association maintains links between the two countries.

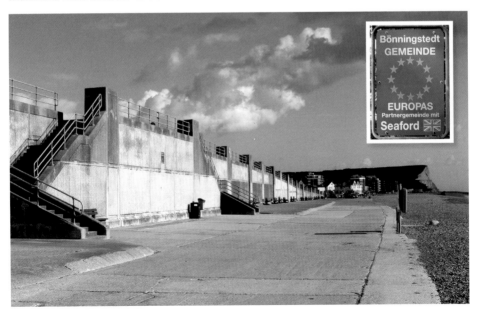

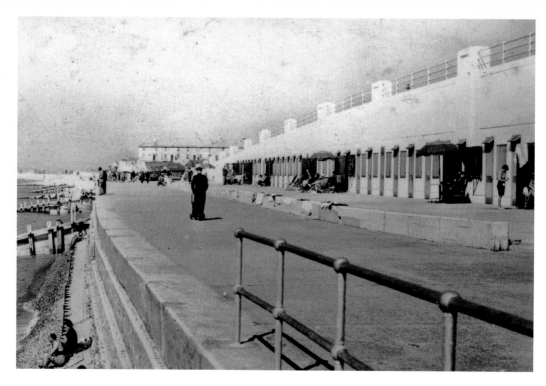

Bonningstedt Promenade

This view shows the Bonningstedt Promenade looking west towards Newhaven. The beach chalets and the old Coastguard Cottages can be seen. The pictures also clearly show how the sea defences have dramatically changed the beach.

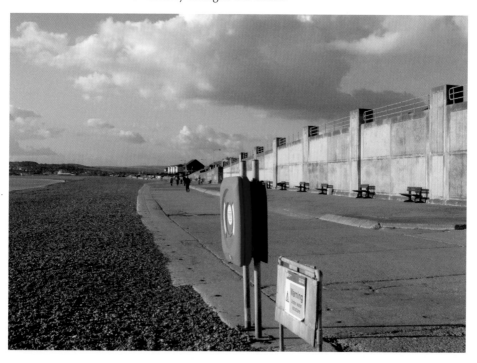

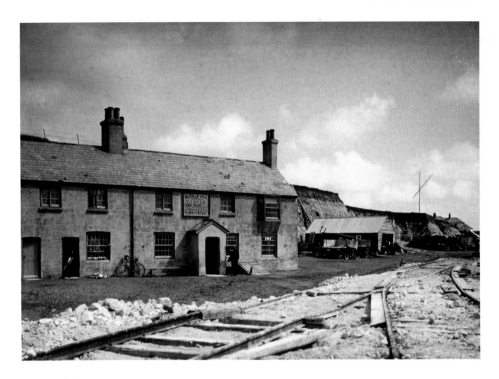

The Buckle Inn

The Buckle Inn stood at the western end of Marine Parade for nearly 200 years. For many years the pub was run by Tom Venus who is buried at St Andrew's Church, Bishopstone. Note the railway lines in the foreground used to move chalk for sea defences. In 1962 the old pub was demolished and replaced with a new building, which for a short time also served as a pub but is now a private residence.

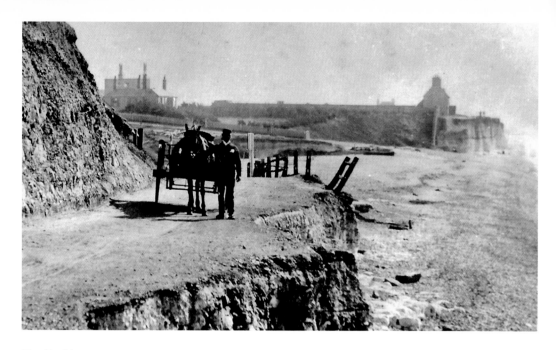

The Buckle

The Buckle was the symbol for the Pelham family. On 18 July 1545, Sir Nicholas Pelham fought off a French incursion at this spot which was known as the Battle of the Buckle. Although the views show how much chalk was removed from the seafront area, Claremont Road is visible in both scenes.

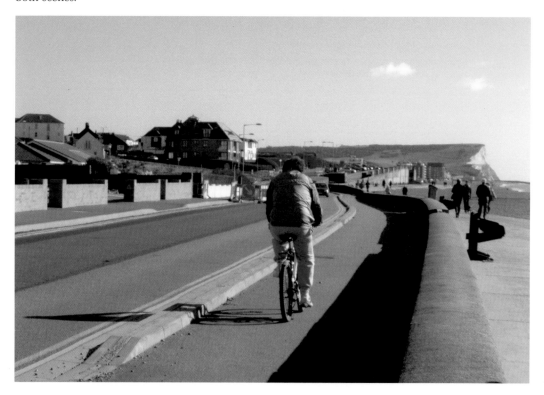

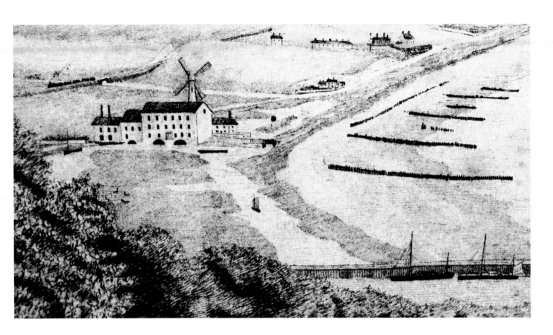

Seaford Bay

The view above was drawn by local artist Harry Evans (1849-1926) standing at the fort on Castle Hill, Newhaven. He has drawn the Tide Mills, which were built here in 1761 by three grain merchants from West Sussex. The windmill was used to run machinery rather than grind corn. A train is passing over the Buckle railway bridge. Hawth Hill was developed after the war and the by-pass added in 1964.

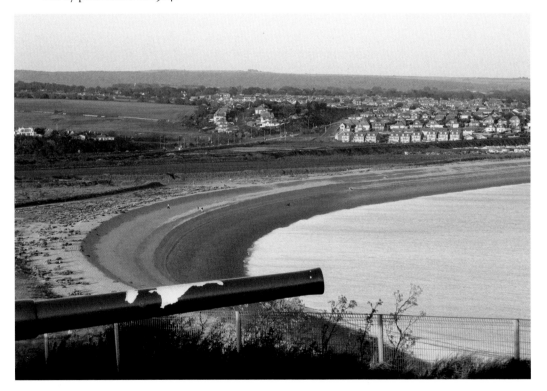

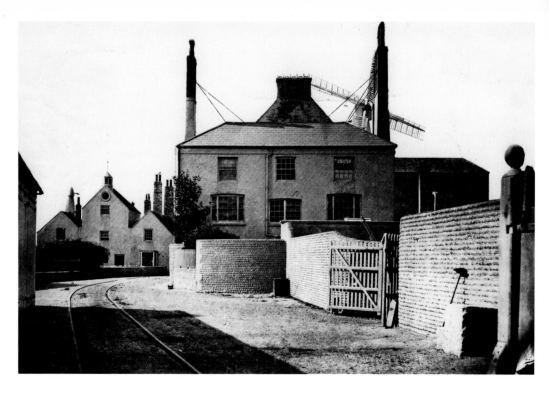

Tide Mills

The tide mills were expanded by William Catt (1780-1853) after he took over the site in 1801. He increased the working millstones from five to sixteen and soon had the contract for supplying food to all the troops stationed on the coast between Portsmouth and Dover. The railway line was added in 1864. Kale House and the Mill House can be seen in this view. The village was demolished in 1938 and the only part recognisable today is the small section where two flint walls meet.

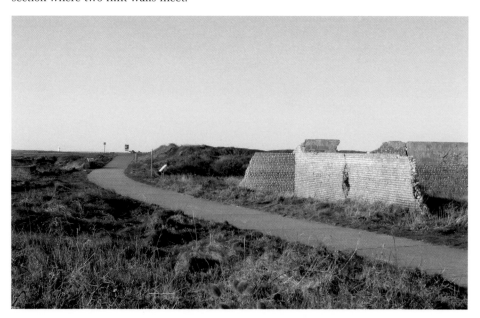

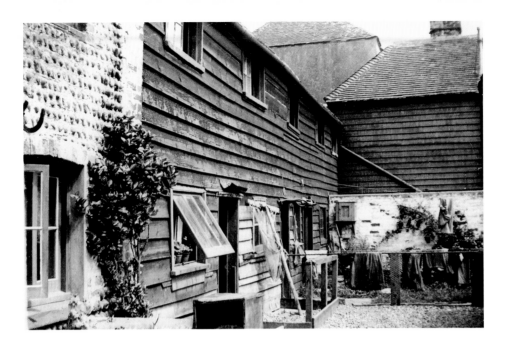

Discovering a Lost Village

About sixty people worked at the mills and many lived there. Details of village life is being uncovered in a variety of ways; old photographs show the old cottages and since 2007 the Sussex Archaeological Society have been excavating the site. The above picture shows prawning nets and overalls drying on a makeshift line. The archaeologists below are uncovering the former Stationmaster's Cottage.

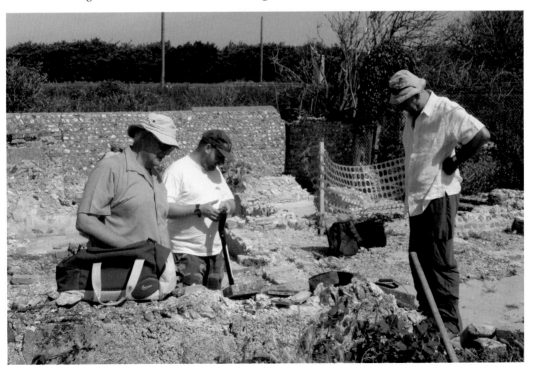

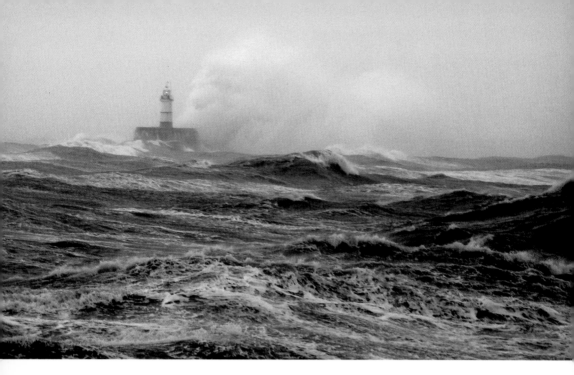

Seaford Bay
The bay can be a photographer's delight with spectacular sunsets, particularly in the spring and autumn. During rough weather, the lighthouse at the Newhaven Harbour Arm is often obscured by the crashing waves.

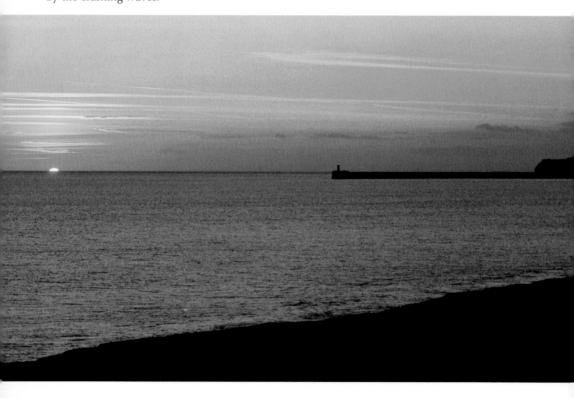

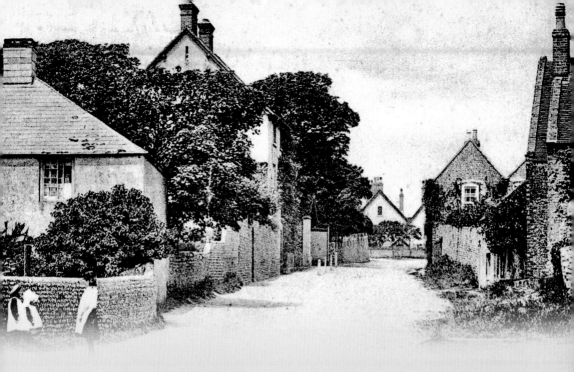

CHAPTER 5

East Blatchington

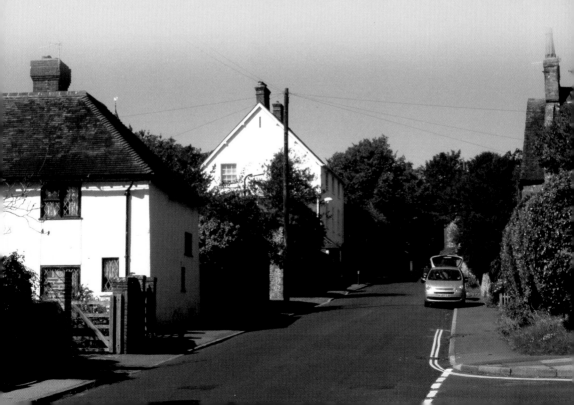

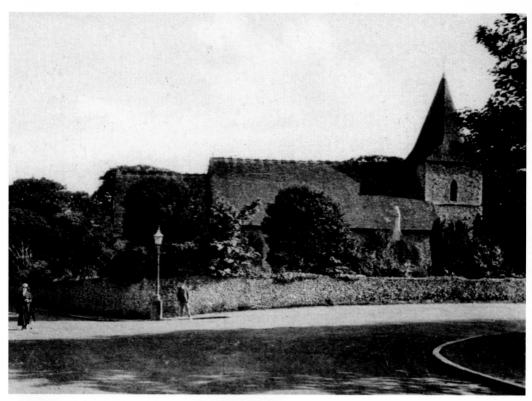

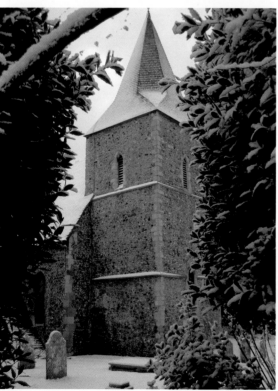

St Peter's Church

St Peter's Church dates from the twelfth century and the tower was built about 100 years later. The list of rectors dates from 1257 when Hamo de Warenne held the post. Robert Dennis was the vicar here from 1844 to 1880. He was a naturalist and his diaries list all the birds he saw including puffins, oriels and ospreys. Unfortunately more often than not he shot them!

Blatchington Hill

Although East Blatchington has now been surrounded by suburban Seaford, it was once a separate village with its own church and pub (the Star Inn). This scene, at the top of Blatchington Hill is now a busy roundabout but 100 years ago it was much quieter. A horse-drawn cart is seen in the upper view and below military volunteers arrive for a nearby camp in 1906.

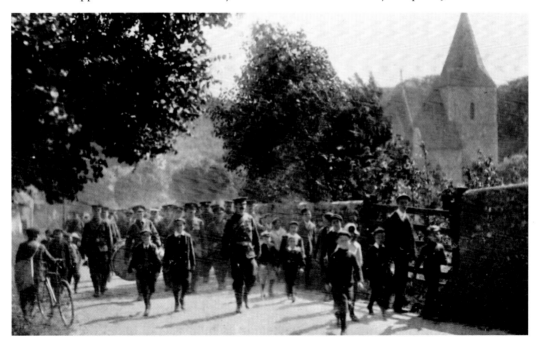

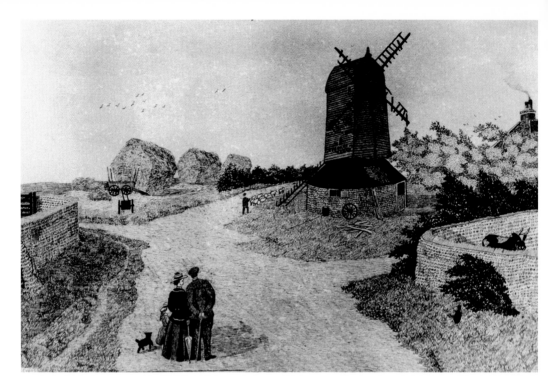

Blatchington Windmills

The base of Blatchington Mill (above) also known as the Black Mill can still be seen in the garden of a house in Firle Road. It was in place in the early 1700s but was demolished in 1878. Further up Firle Road, a pumping mill (below) was built in 1894 to draw water from an underground reservoir. The water was brackish and the mill was only used for a few years.

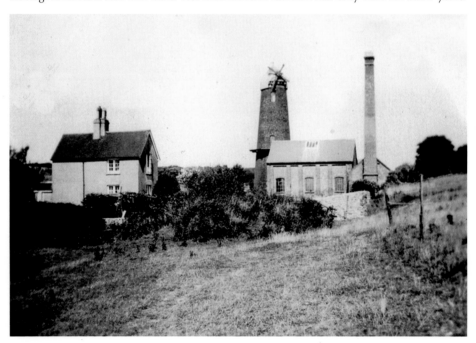

Alce's Place

In 1652 J. Alce left a will which refers to a barn and farm buildings in Blatchington. In 1822 the farm was purchased by John King who lived at Blatchington Place and owned most of the village. It was sold on to the Lambe family of Blatchington Court and stayed as a farm until 1912 when some of the fields became the home of Seaford Cricket Club. The farm buildings were sold in 1956 for £8,500 and converted into homes.

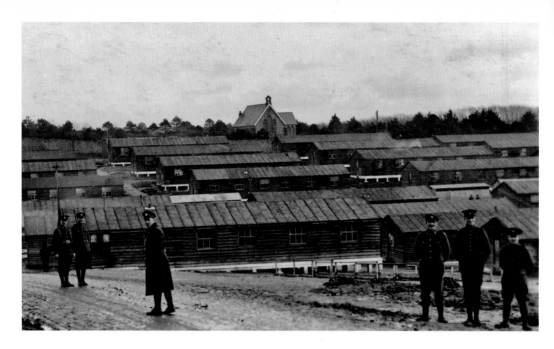

North Camp

As well as the South Camp (page 63) another, larger camp was built on the land between East Blatchington and the cemetery, (the chapel of which can be seen in the picture above). As well as training facilities, the camp also held Conscientious Objectors. A wooden hut from the camp remained in North Way until the 1990s. The streets around Belgrave Road and Lexden Road have now been built on this site.

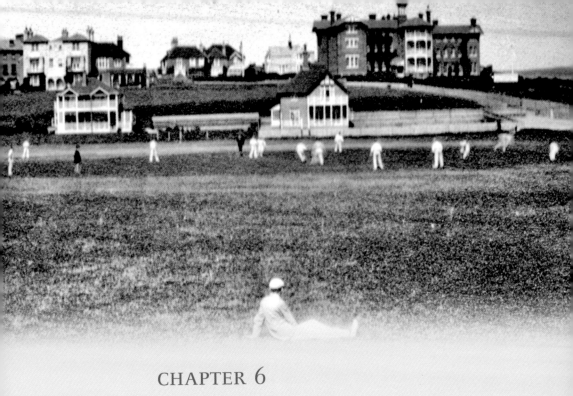

CHAPTER 6

Sports & Entertainment

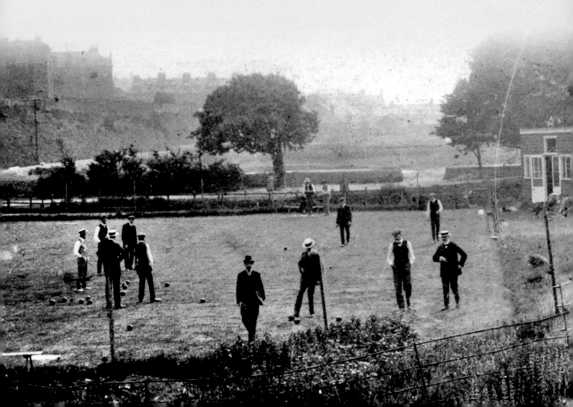

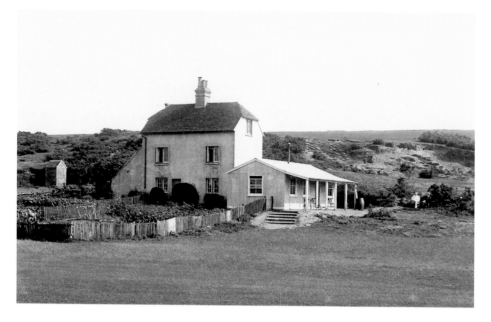

Seaford Head Golf Club

Golf had been played on Seaford Head for many years but on 6 August 1887 a golf club was formally established. Mr John Thompson of Felixstowe was commissioned to design the course which was the second in Sussex and one of the first in the country. The land was grazed by sheep and the shepherd, Ruben Russell lived in a nearby cottage which became an unofficial clubhouse. In 2010 it was announced that a new building would replace the current wooden clubhouse buildings.

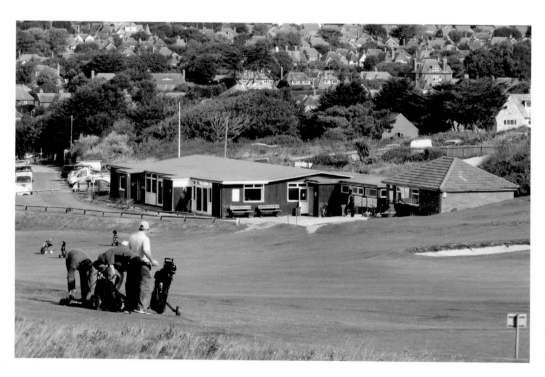

Seaford Golf Club

Seaford Golf Club was established in 1907 at Bullock Down to the north of East Blatchington and the first President was Viscount Selby, the former Speaker of the House of Commons. The new club benefitted from having a smart new club house which gives splendid views over the course and downland.

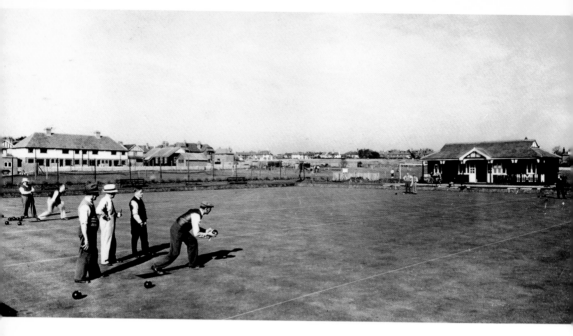

Bowls

Seaford Bowls Club was established in 1910 and a green was laid out in Chichester Road (see page 89). In 1934 another green was laid out by Seaford Council in the Crouch Gardens. This became a popular venue but in 1942 the Vice-Captain and Secretary were killed in an air raid and many records and trophies were destroyed. The pavilion was extended in 1973 when a ladies team was formed.

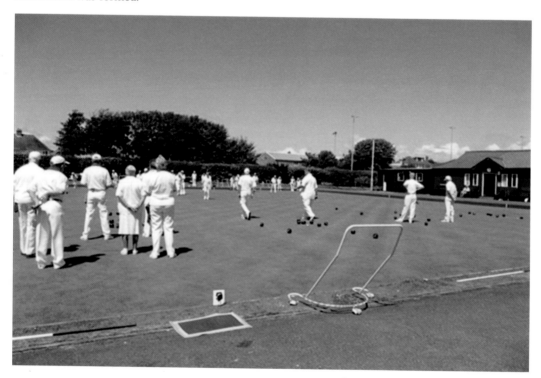

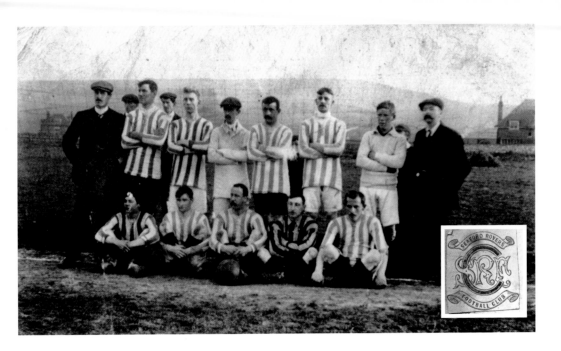

Football

This picture shows Seaford Rovers football team in about 1900 who, like the modern team, Seaford Town FC, played at the Crouch – but not without interruption. In July 1917 the pitch was ploughed up to provide allotments for the war effort. In 2010 the ground was improved when a new stand was built. The picture below shows Seaford Town playing a Brighton & Hove Albion side at a charity match in 2009.

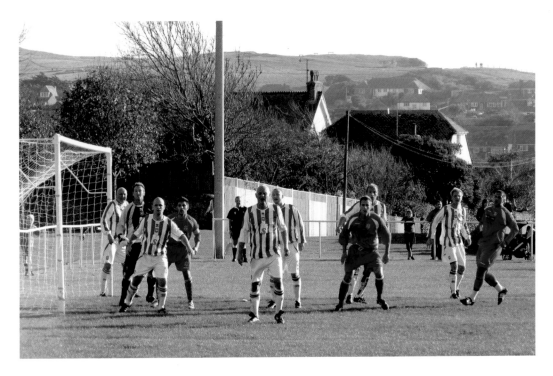

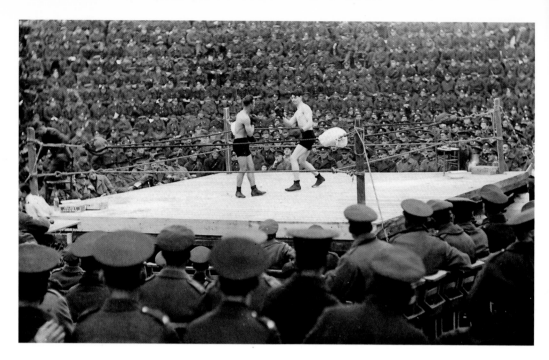

Seaford for Sports

The town has always been the venue of sporting competitions, with tourneys and sports days being regularly held. The view above shows a huge crowd who have turned up at the makeshift arena in the North Camp to watch Fred Rye of Kentish Town fight Corporal Attwood of the Canadian Machine Gun Depot. The view below shows Seaford's Mayor, Councillor Tracy Willis starting the Seaford Half Marathon from Martello Fields in 2009.

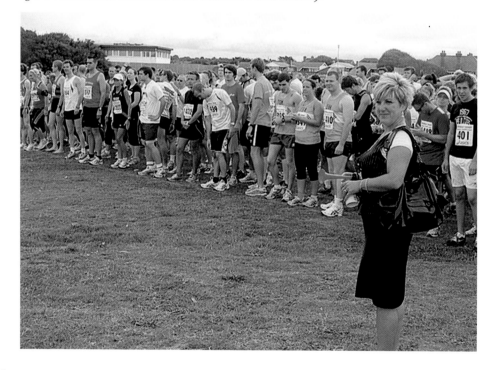

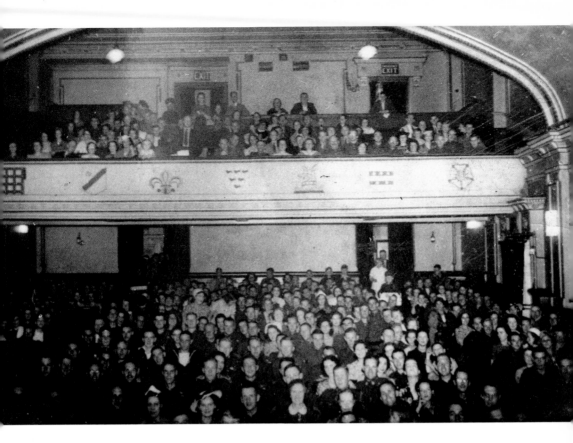

Cinemas

The Empire cinema stood in Sutton Road from 1913 until 1937 until 1939 when it was destroyed in a fire in which local fireman Fred Mace was tragically killed. The view shows the interior of the cinema which could seat 500 people. In 2010 a plaque commemorating Fred was placed at the site and his name was added to the National Fire Brigade Memorial at St Paul's Cathedral. The Ritz cinema stood on the corner of Dane Road and Pelham Road from 1936 until it closed in 1980. It was later demolished to make way for a supermarket.

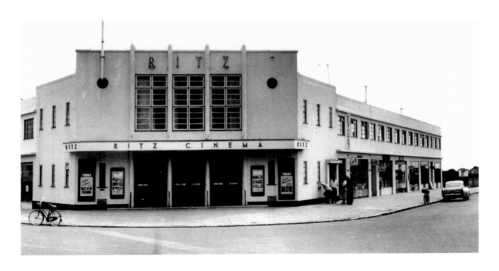

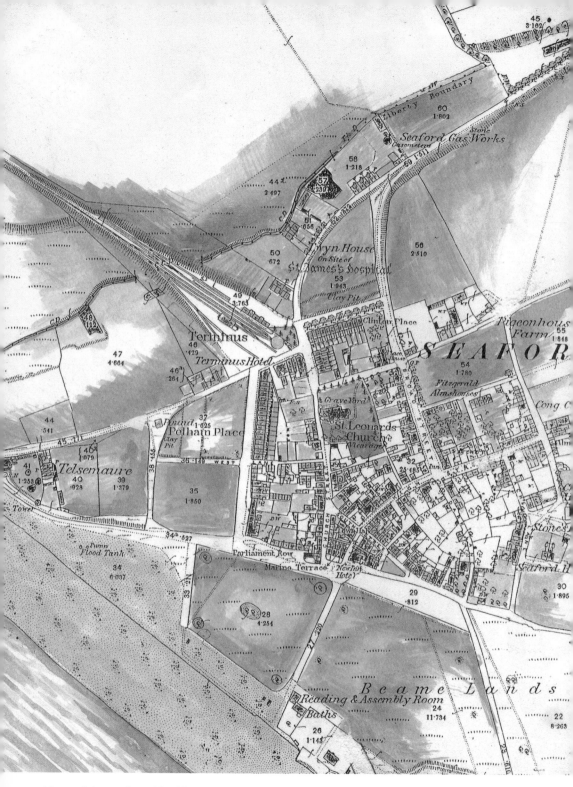

Many of the roads and buildings mentioned in this book can be seen in this map of Seaford from 1870.